MEXICAN
COLOR

Revimundo México

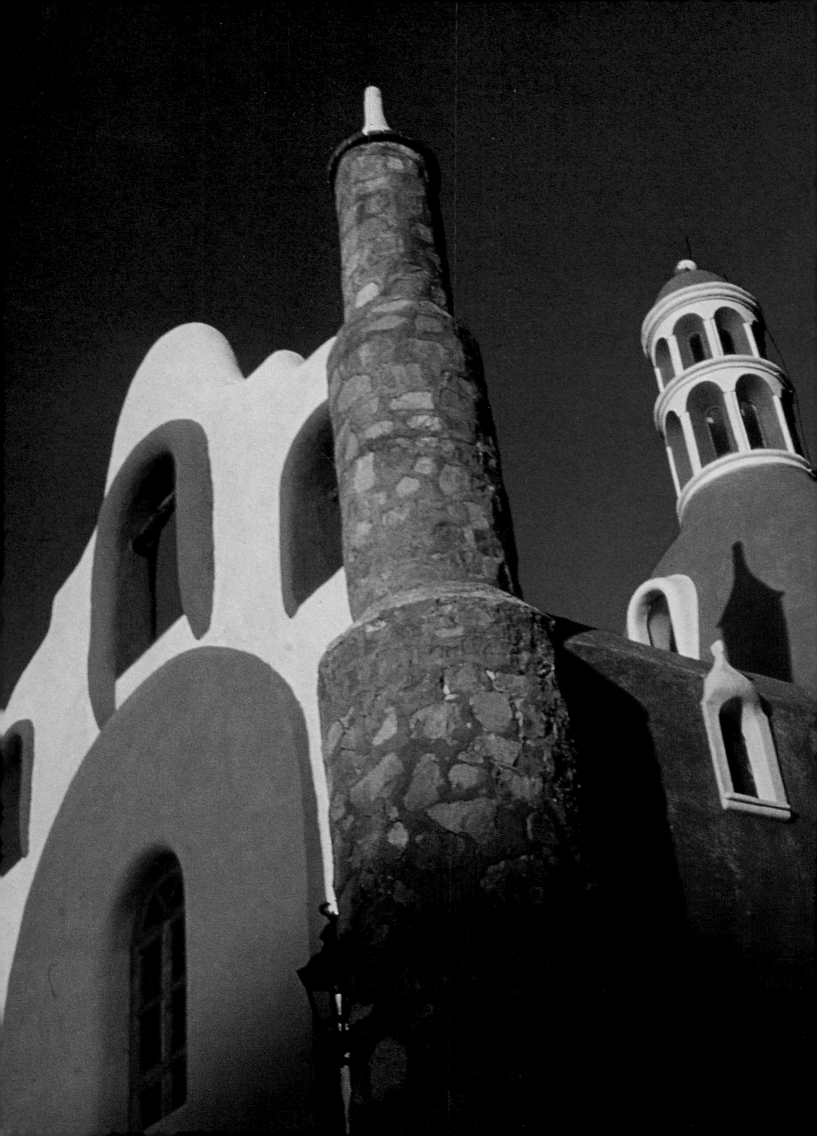

MEXICAN COLOR

Photographs
AMANDA SEVILLE HOLMES
Introduction & Essay
ELENA PONIATOWSKA

REVIMUNDO
MÉXICO

Published in 1998 and distributed in the U.S. by
Stewart Tabori & Chang,
a division of U.S. Media Holdings, Inc.
115 West 18th Street, New York, NY 10011

Published in 1998 and distributed in Mexico by
Revimundo, S.A. de C.V.
Mariano Escobedo 220-B, Col. Anáhuac, 11320 Mexico, D.F.

Distributed in Canada by
General Publishing Company, Ltd.
30 Lesmill Road
Don Mills, Ontario, Canada M3B 2T6

Sold in Australia by
Peribo Pty. Ltd.
58 Beaumont Road
Mount Kuring-gai, NSW 2080, Australia

Distributed in all other territories by
Grantham Book Services, Ltd.
Isaac Newton Way, Alma Park Industrial Estate
Grantham, Lincolnshire, NG31 9SD, England

Library of Congress Cataloging-in-Publication Data

Poniatowska, Elena.
Mexican Color / photographs by Amanda Holmes; written by
Elena Poniatowska.
p. cm.

ISBN 968-7294-05-1
Spanish language edition ISBN 968-7294-06-X
1. Art, Mexican. 2. Architecture—Mexico. 3. Color in art.
4. Color in architecture—Mexico.
I. Holmes, Amanda. II. Title.
N6550.P66 1998 98-17169
701'.85'0972—dc21 CIP

Printed in Italy

10 9 8 7 6 5 4 3 2 1

Developed and produced by
Gary Chassman

Burlington, Vermont

Book design Bill Harvey

Production assistance
Michelle Newkirk Fairchild, Steve Wetherby

The text of this book was set in Fournier,
with the captions set in Franklin Gothic.

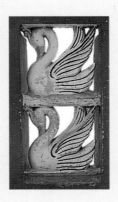

Acknowledgments

I would like to thank my parents for their amazing support and encouragement through the years; my brother and sister for their professional advice; Rogelio Espinosa, who ran around for me when I could not walk; and Jose de Yturbe, Manolo Mestre, Diego Villaseñor, Andres Casillas, Luis Barragán, and Ricardo Legorreta for making such fabulous houses and buildings. Special thanks to John Wiseman, and Gary Chassman, who believed in this project from day one, and to Bill Harvey for his patience and talent. Thanks also to Suzie Moir and Cristobal Egerstrom, who so graciously made many photographs possible; to Isabel Goldsmith for her kind and generous hospitality, to Marie Pierre Colle Corcuera for her guidance, and to Francesca Saldivar for her support and enthusiasm. My deep appreciation to Emilio Guerrero for his wonderful stories, and to Stephenie Hollyman who taught me so much about the world of photography. A heartfelt thank-you to James Ramey for his never-ending enthusiasm, Eugenio Aburto for helping in so many ways, and Jennifer Clemints for her good ideas; to Lawrence Weiner for his professional advice; Tatiana Falcon for all the information; Marco Antonio Pacheco, Jaime Navarro, and Gabriel Mestre for helping me during my immobile state. A thank-you also to John and Colett Lilly for their extensive knowledge of Mexico, to Inez and Cesar Cordova for the opportunity to photograph their house, and to Aurora Camacho for her amazing and speedy translation. Thanks are due to these wonderful people for all their help: Frederic Clapp, Luis Enrique Noriega, Martin Garcia-Urtiaga, Michael Calderwood, Ana Paula Pous, Norma Soto, Federica Zanco, Jaime Benavente, and Duccio Ermenegildo. My deep appreciation to all my friends who supported me through this project and especially to the people whom I met during all my travels in Mexico. A very special thanks to Elena Poniatowska for her essay and for her inspiration and professionalism.

This book is dedicated to Mommy and Papa.

For further information about photographs, please contact:
Amanda Seville Holmes, Mariscal 70, Col. San Angel Inn 01060, Mexico City D.F. email: mexican_colorash@hotmail.com

HALF-TITLE PAGE: *San Miguel de Allende, Guanajuato City.* Detail of tiles and red wall. TITLE PAGE: *Guanajuato City.* La Santísima, now a restaurant overlooking the city. ABOVE: *Campeche City.* Carved white swans nestle in the pink wall. OVERLEAF: *Careyes, Jalisco.* Casa Parasol. Architect Diego Villaseñor. Interior of cylinder with steps. The interior is bright orange, a color adopted from the surrounding nature. The light at this time of day reflects inside the cylinder enhancing the orange color. Careyes Casa Dos Estrellas. Architect Manolo Mestre 1995.

Introduction

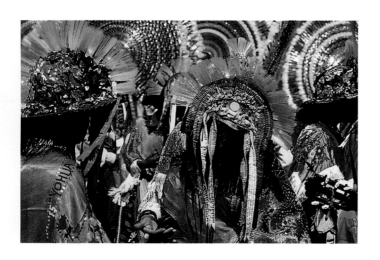

IN THE CHILDREN'S FANTASY, the child with the green ribbon has to run; he must get to the forest and paint every tree in green. The Old Woman fails to catch him, so she must go back to the circle of young singers and ask for another ribbon, a yellow one this time. Ah! The child with the yellow ribbon escapes her, too, and she covers the fields of wheat and maize, the sand of the sea, and the straw hats of all the people. Then comes the little child with the blue ribbon; she takes one big leap to the sky, opens her arms, and spreads her sky-blue powder up high.

—Knock, knock.
—Who is it?
—The Old Woman!
—What do you want?
—A ribbon!
—What color?
—Green!

Here is the little boy with the red ribbon, running, running, taking shelter in the apples of Zacatlán and in the threads of the weavers of Chiapas. The Old Woman stretches her arm and grabs him; she shakes him hard, and some of his color spills over the tiles of the house roofs and onto the cheeks of young women.

Red is the first color to appear in any culture. It is the bridal dress of Chinese women, the one on the flag, the color of the Mexican motherland,

ABOVE: *Quetzalan, Puebla.* Twice a year all the people from the nearby small towns gather around this square to have the candles for their churches blessed. RIGHT: *San Miguel de Allende, Guanajuato.* The evening light enhances the colors of the San Miguel de Allende walls while a young woman sits, selling tortillas.

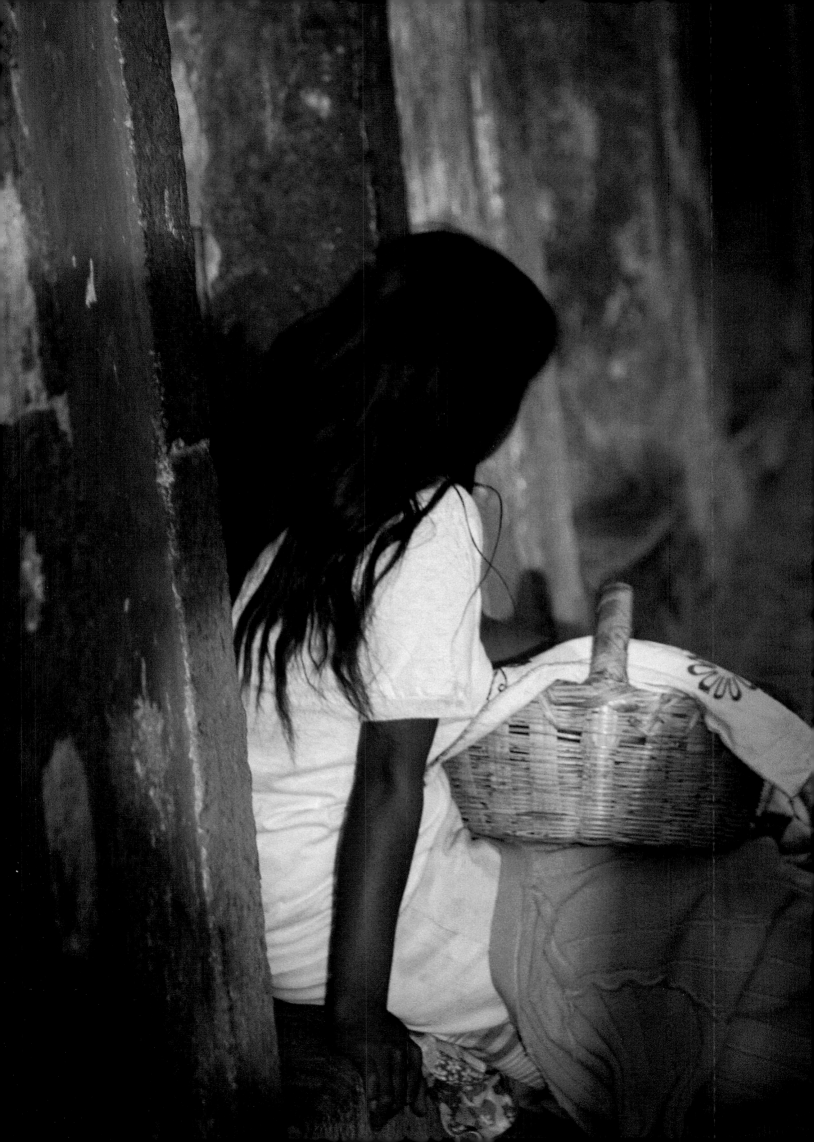

war, sovereignty. Red is the color of the king's mantle, the royal carpet, and the robes of cardinals in the Church. Red is the coat of Little Red Riding Hood and of the stop signs that tell us to STOP in English. Red is the color of danger, hearts, and love. If envy is green, then hatred must be red because it is the other side of the coin. Red is the anger that raises our temperature and makes our faces burn. High pressure is red, and so is shame, especially the shame the innocent feel, the boys and girls still capable of blushing.

—I want a pink ribbon!

The Old Woman asks for more and more, and the game never ends. The children with the red, yellow, and blue ribbons believe themselves to be important, because theirs are the colors that can make all others, even if none can compare to red. The Old Woman never catches the children—she is not the Old Woman for nothing. They are all faster than she is, and they've all taken shelter in Nature. The Earth goes around and around like the circle of children who dream of blues and yellows and oranges, waiting for the Old Woman to come back and pick out a new ribbon. Meanwhile, all colors sing.

Colors rise with the daylight and with the light of truth. The child with the green ribbon is green until the end of the game. His ribbon, like emeralds, is an antidote for all poisons. Sapphire blue is a symbol of purity. The purple amethyst is a dreamy girl with a shy smile that dispels all sorrows. Jade is good for fertility. Topaz, as anything yellow, awakens joy. The pale gray agate condenses sweetness in the eyes of grandmothers.

—What color do you want, Old Woman?

—I want a white ribbon, but this time I will close my eyes and count to three while you run ahead.

PREVIOUS PAGES: *Tulum, Quintano Roo.* The first impact upon seeing Tulum, aside from the turquoise sea, is the array of colors in the hammocks that contrast with the serene white sand. ABOVE: *Oaxaca City.* Plastic sheets in typical colors. RIGHT: *Careyes, Jalisco.* Traveling palm.

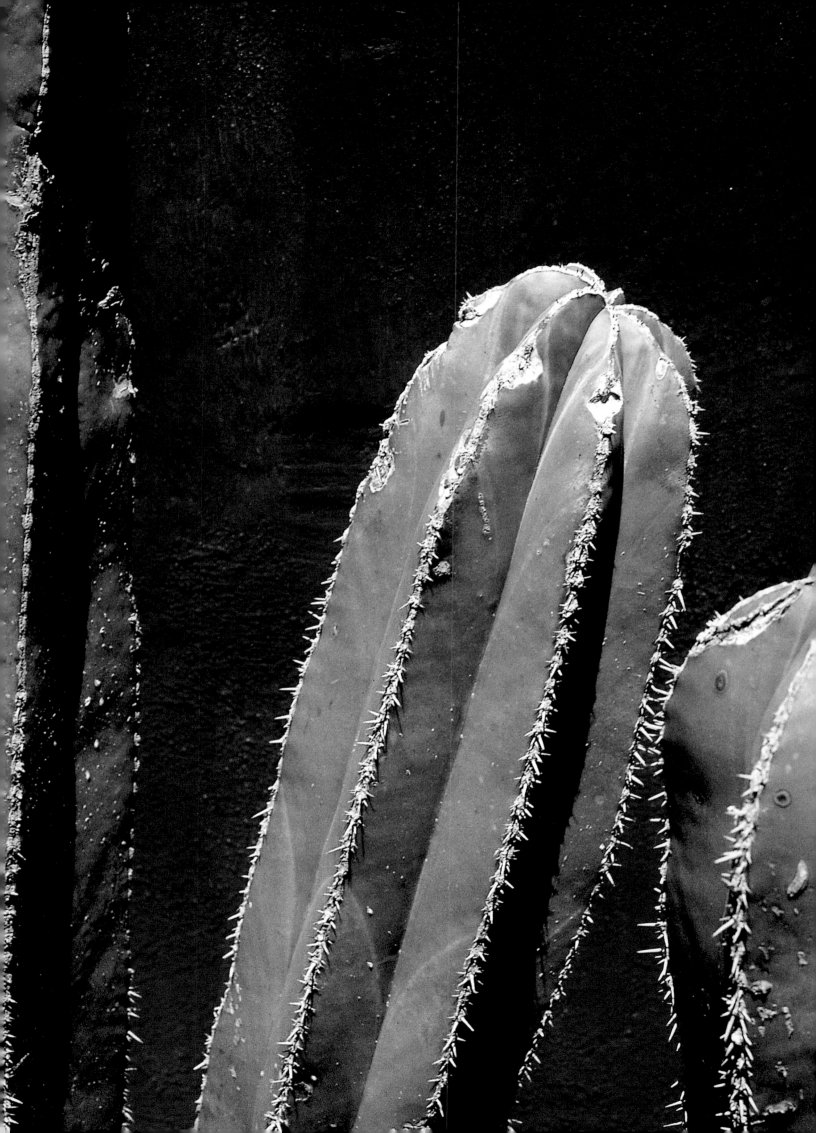

The child with the white ribbon flies on legs whiter than milk all the way to the North Pole. They say that Eskimos can discern seventeen shades of white, even though we consider white a non-color. The child adds his own whiteness to the immense whiteness of snow. In Mexico, we only know snow on the tops of our mountains, and white on the pants that some men wear and in the teeth that flash inside the darkness of a face. In my country, peasants wear white calico, and on Sundays they go to Mass clean as Easter lilies, upright as the calla lilies that Diego Rivera painted.

—Knock, knock.

—Who is it?

—The Old Woman!

—What are you looking for?

—A black ribbon!

No child ever chooses black; nobody wants to be the black ribbon because black is the absence of color, the color of nothing. Only an eleven-year-old-girl claimed to be the black ribbon. She said there was nothing better than lying on her back and looking at the night sky, joining the constellations with an imaginary line of soft light. The Old Woman was forced to look for her in the dark, among the stars.

—Child, have you become the night?

The little girl with the lilac ribbon is the youngest of them all. She gets tired of playing with the mischievous child who is the pink ribbon. She reaches the horizon and falls asleep. Her gentle breathing dyes the air: this is why a sunset ends up as a kitschy photo on a postcard of indelible colors, so bright it is not believable.

In real life, true colors fade with time and are dimmed by use. Wind, rain, sunshine, they all contribute to dulling the ribbons requested by the

LEFT: *Huasca, Hidalgo.* Rancho Santa Helena. San Pedro cactus with a typical pre-Columbian red wall. ABOVE: *Oaxaca City.* Giant taro.

Old Woman; except for brown, the most enduring and reserved of all colors. The circle of children holding hands loses its innocence. The Earth spins, hurling its colors. It spins until it turns into a ball of fire that will extinguish itself in ten thousand trillion years, becoming an opaque body, gray, made out of scorched cinders.

Curiously, the color that fades fastest is the most energetic one: red. To be dressed in red is to call attention to oneself. On the other hand, no one dressed in yellow can be thought to be discreet, not even a canary. They say that "she who wears a yellow dress must trust her beauty." Jaundice will paint one's eyes yellow, and may be a sign of a mortal disease. Yellow is the color of "bad," as in, yellow journalism. New York cabs are yellow, with drivers who spread bad news at awesome speeds, along with dark political analysis, as dark as their own speedy consciences.

In Mexico we copied the New York yellow for our own taxis, and now they materialize as lifesavers in a river of vehicles of many colors: white, metallic green, black, navy blue, pale green, green and silver, burgundy, scarlet red, beige and tan, turquoise (yes, turquoise)—maybe even the fantasy of a golden Cadillac with a platinum blonde who looks like Marilyn Monroe.

During the sixties, corrupt leaders of big unions loved their golden Cadillacs. Their cars flashed under the sun, their steel-gray suits blinded others: "Hey! Do you go to a tailor or a tinsmith?"

No wonder the Beatles could sing that we all live in a yellow submarine.

"High yellow scream!" says Octavio Paz.

In Mexico, colors are loud and tall. The colors of our flowers are violent: the incendiary crimson of the flamboyant blossoms and the

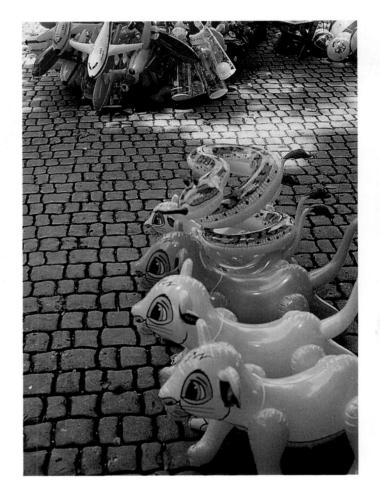

ABOVE: *Oaxaca City, Zócalo.* Each street vendor is accorded a location on the *zócalo* based on seniority, until they have gained what is considered the best spot. RIGHT: *Oaxaca Market.* These pots seem to be normal size but they are actually miniature. The smallest is about a one-half inch in diameter. Oaxaca is well known for its crafts.

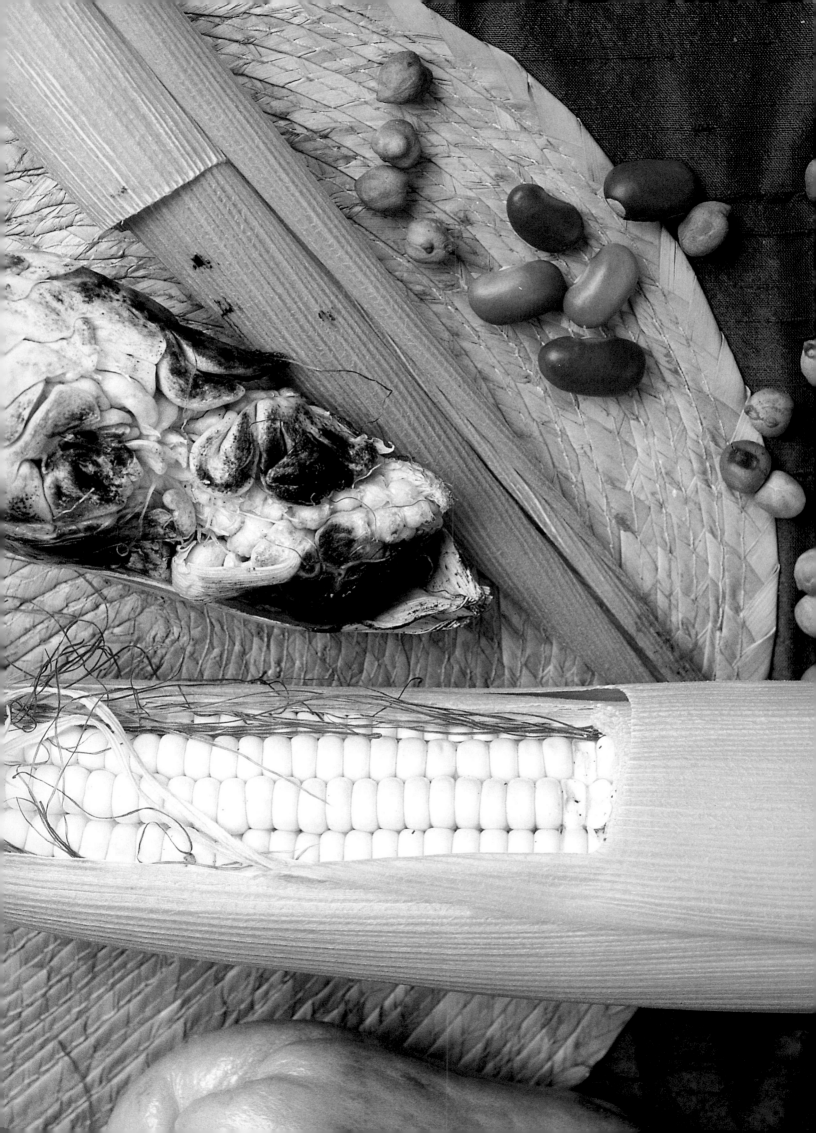

bougainvillea on the walls of Cuernavaca; the striking red of the hibiscus; the scarlet hue of dahlias, our national flower; and the strident, unsettling yellow of *cempazúchitl*, the flower that covers the land on November 2nd, and comes out of the mouths of the dead. There is "the blue iris that couldn't be more purple," as the poet Carlos Pellicer wrote. There is also the cherry orchid with fleshy lips, not petals. Flowers woo us; they are sensuous and loud, with their colors that assert themselves and are strong, rotund, fiery, ready for blaze and for ecstasy.

There is so much light in Mexico that even corn comes in four colors: white, yellow, blue, and black. Wheat, by contrast, is always the same.

Dark bread is the punishment of prisoners.

The culture of corn confronts the culture of wheat. They say wheat is more nourishing than corn, and that those who eat it have more brain cells than those who do not. Still, the Men of Maize are the true men, faceless ones according to the Popol Vuh, sacred book of the Quiché Indians of Guatemala, written during the Spanish conquest. They are mountain, river, winds and water. They are fruit and flower. Women had to chew kernels of corn in order to give birth to the Men of Maize. They ground the corn with their teeth and made a paste to make the human race, and with that paste, it is said, they also made the saints of the Church, molded in colonial times by the dark hands of indigenous artisans.

Writers have sung the light in the Valley of Mexico. Alfonso Reyes called Mexico the place "where the air is clear." Octavio Paz spoke about "the light that beats the ground with its great invisible hammers." According to Paz, stones can feel. This is why he wrote "Sun Stone," his great poem. Many artists came to Mexico in search of

LEFT: **Typical Mexican vegetables: huitlacoche, corn, camotli, and nuts.** ABOVE: *Mexico City.* **Colorin tree flower. This red flower is a delicacy. It is served with nopal. Nopal is the leaf from the prickly pear cactus.**

light, so different than the light they knew: Jean Charlot, Pablo O'Higgins, Elizabeth Catlett, the sisters Marion and Grace Greenwood, Edward Weston and Tina Modotti, Katherine Anne Porter, Emily Edwards, Henri Cartier Bresson, Paul Strand, Pierre Brasseur and Hart Crane; the Mayan archaeologists Eric S. Thompson and Paul Kirchoff; the surrealists André Breton, Benjamin Péret, Remedios Varo, Leonora Carrington; from Russia, Sergei Eisenstein, and still others from the United States, like Malcolm Lowry, Jack Kerouac, Allen Ginsberg, and the great filmmakers who fled the McCarthy persecution, accused of being red, like Dalton Trumbo, author of the 1939 novel and extraordinary film—the best antiwar film ever made—*Johnny Got His Gun.*

In European cities like Paris, Berlin, London, and Dublin, lack of color means good taste. What is required is uniformity and discretion. Even the sun is timid. It barely shows itself on the roofs of the houses, and sometimes it doesn't show itself at all. Pale, it looks like an uncooked crêpe. The stone does not acquire color, because there is no light. Walls are gray or white, and the only green that is acceptable is the green of window shades and awnings, the benches in public parks, and the verdant hues of domesticated vegetation. European aesthetic precepts condemn shrill colors. "Such bad taste! What vulgarity!" The canons of beauty are still the classical ones. Greek temples were white, and the sun and the blue sea were reflected in them. The Parthenon of the goddess Athena is white, and white are the dresses of the little girls on their first communion day, as they let the white host sit on their strawberry tongues. White is the dress of the bride who comes before the altar on her father's arm. White are the handkerchiefs of our grief and our

ABOVE: *Tzintzuntzan, Michoacán.* This detail of a gravestone is elaborately decorated for Day of the Dead. RIGHT: *Tlaxcala City.* Sitting in an outside café, one can not help but notice these paper cutout decorations. It is an effective way to decorate a space. Traditionally, the paper cutouts were used only on the Day of the Dead. Now they are seen more frequently.

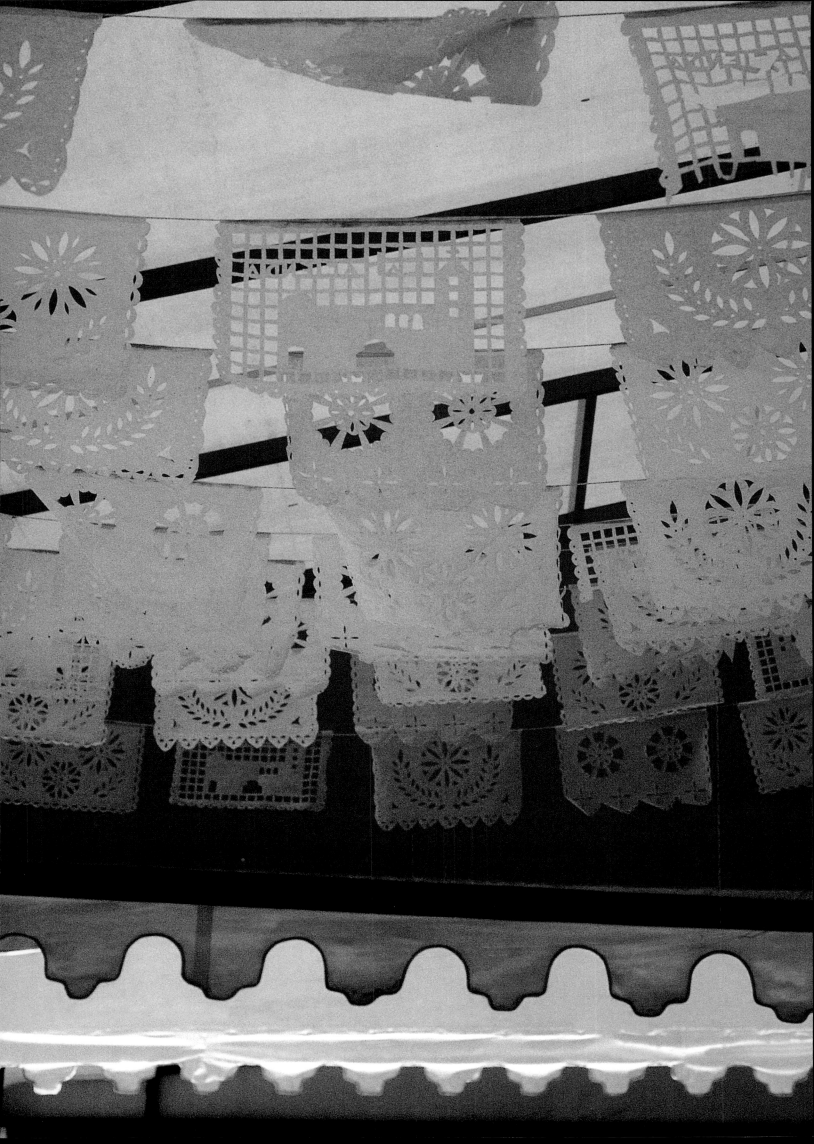

farewells as they are waved in the air like doves. To raise a white flag is to give a sign of peace and of surrender.

Blue became synonymous with integrity, loyalty, and honesty. Blue and white—those were, and still are, the Christian colors. The robe of Our Lady of Lourdes is white, with only a blue sash to upset the balance. And balanced also is European architecture: elegant, monochromatic, gray, because it only knows one color: the white that ages into gray. Distinguished white color! It never disrupts harmony or pulchritude; it is never vulgar, it does not provoke. Monochrome maintains tranquility. Nothing bad can happen behind a peaceful façade that gives everyone a sense of uprightness. Uprightness first of all, a moral trait can also be a visual quality.

In 1750, the discovery of Pompeii and the great mural paintings in the interiors of its homes demolished strictures and totally changed the laws of aesthetics. The daring Pompeian colors dazzled. They dared to hurt the human retina, and to leave an imprint on it. What a challenge! Suddenly polychromia became a rooster waking up the world with its cock-a-doodle-doo. Already Italy was ocher and orange, and its monuments, temples and buildings radiated light.

—*Elena Poniatowska*

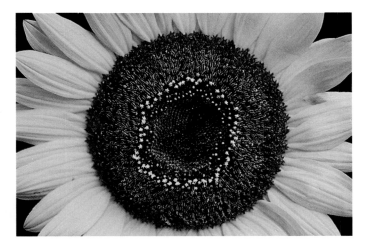

LEFT: **Maguey cactus.** ABOVE: **Tepoztlan, Morelos. Chrysanthemum.** BELOW: ***Mexico City.* Sunflower.**

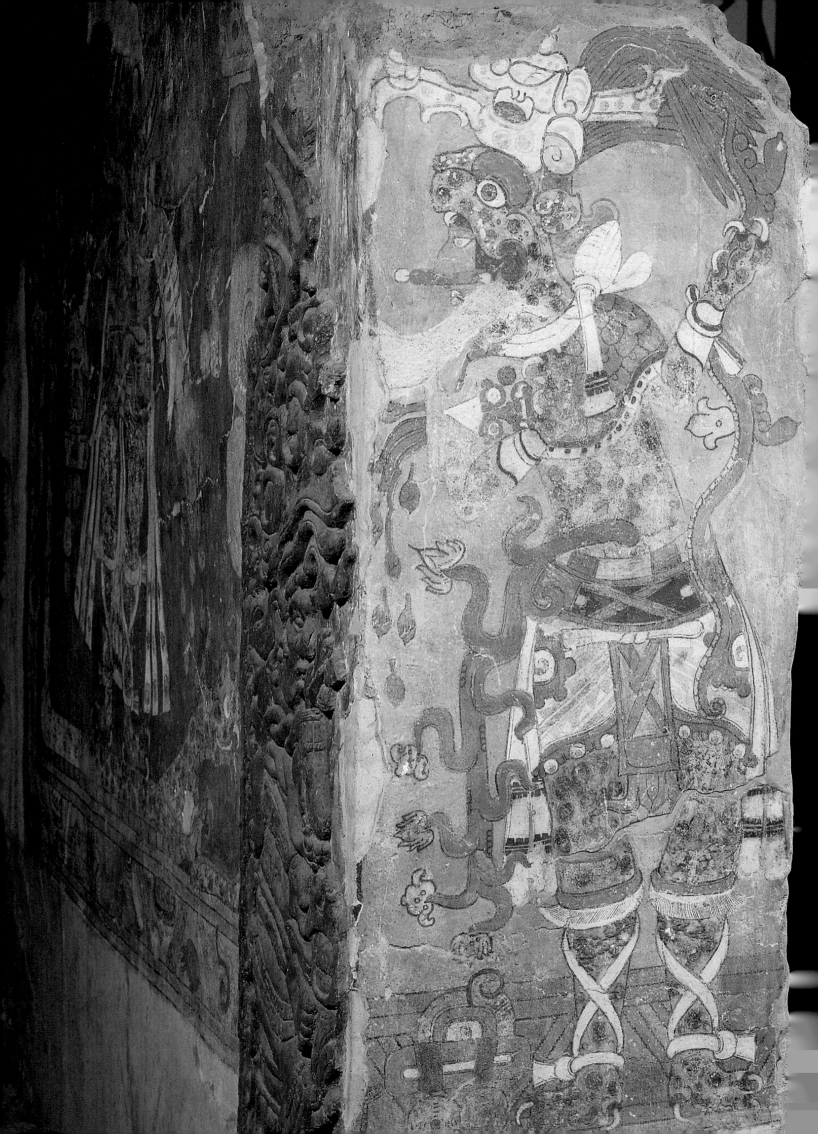

The New World

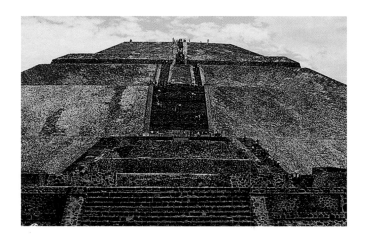

*Knock, knock, knock!
Suddenly Latin America
appeared on the scene
dressed as a parrot,
wearing the most riotous
colors of earth.*

SHE CAME UPON THE STAGE dressed in platform shoes, arms akimbo, and with a fruit bowl on her head—pineapples, watermelons, and bananas in balance. Was there ever any other kind of balance? The severe European stage was shaken up. Latin America, draped in gold, danced to the rhythm of maracas and drums, its discordant beat broken by a shrill cry, a convulsion, a moan. Its lightwaves created sambas, cumbias, salsas, and hip vibrations

LEFT: *Cacaxtla, Tlazcala.* Jaguar Warrior at temple entrance, a symbol of royal power. ABOVE: *Teotihuacan.* Pyramid of the Sun.

deemed indecorous and typical of people from warm climates. Europe decided to warm up its colors, and remembered those that had been preserved underground in the paintings on the walls of the caves of Altamira and Lascaux: those brave bulls that fight against death and triumph over it, proof of human civilization.

If there is color, there is culture; if there is color, there is a mind that had to investigate how to incarnate an idea through painting or through engraving a stone wall. Bonampak, Cacaxtla, Teotihuacán: Here were the artists who "spoke with their own heart," as the Náhuatl philosophy puts it. They mixed in the pigments from vegetable and mineral sources. They rubbed the colored dirt on the surface of vessels and plates. They crushed insects to release their tint. The ground cochineal stained the fabric crimson. Ocher and jade became the pre-Columbian colors par excellence. Perhaps the Mayan blue sprang from an organic pigment fixed on the wall with white clay. Perhaps the Maya made the colors adhere to the walls by using vegetable gums and limestone mixed with water, or

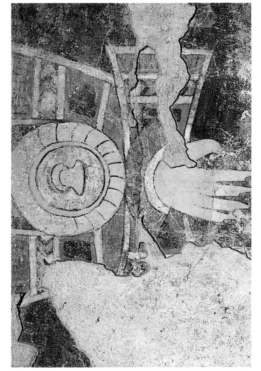

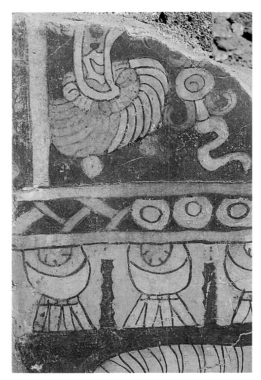

perhaps they thought of animal mucilage, egg white, or even egg yolk. The archeological discoveries made by Manuel Gamio at Teotihuacán brought to light the splendid polychromia of pre-Columbian architecture. Everything had color: sculptures, murals, codexes, friezes, pottery, Quetzal feather collars, robes, bead necklaces, jangling bracelets, earpieces, nose rings, pectorals, and even the human body, covered with emblems and ornaments of many colors. Everything gleamed in the sun. The colors were so vibrant with life that the visual impact was multiplied before the fascinated eyes of the archaeologists. Our history is no small treasure! Silhouettes bearing no correspondence to reality floated over a dark red background, casting a spell. They were abstractions, syntheses, clues, the very essence of what art can and must be. In the Mayan murals vanity, cruelty, combat, and music are exhibited in an exalted and luminous polychromia. In Cacaxtla, the life-size jaguar-warriors painted over a blue background, with their impressive cranial deformation, their feather headpieces, and skirts defeat their

ABOVE: *Teotihuacán*. Tetitla. Detail of hand. Classical period, 100 B.C.–A.D. 700. BELOW: *Teotihuacán*. Tetitla. Very colorful border detail. Classical period, 100 B.C.–A.D. 700. RIGHT: *Cacaxtla, Tlaxcala*. Typical Cacaxtlan hieroglyph, perhaps describing the age of a warrior, or a color guide for other artists.

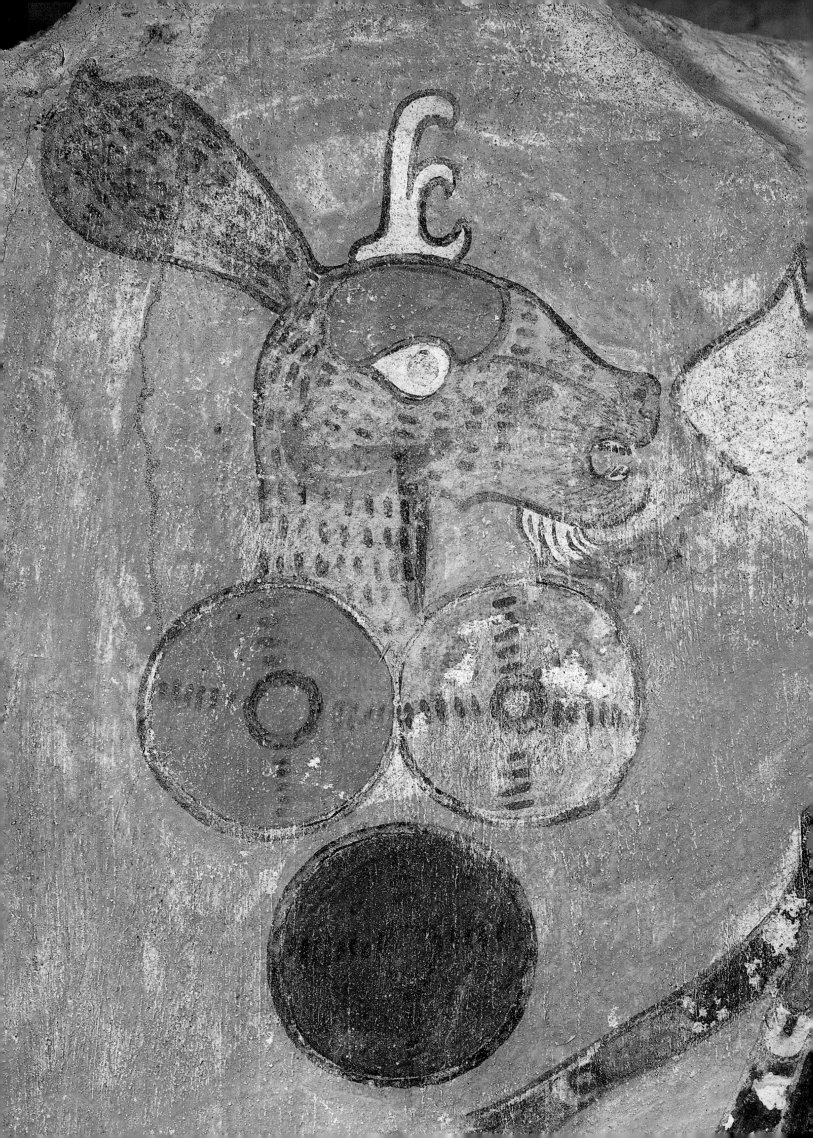

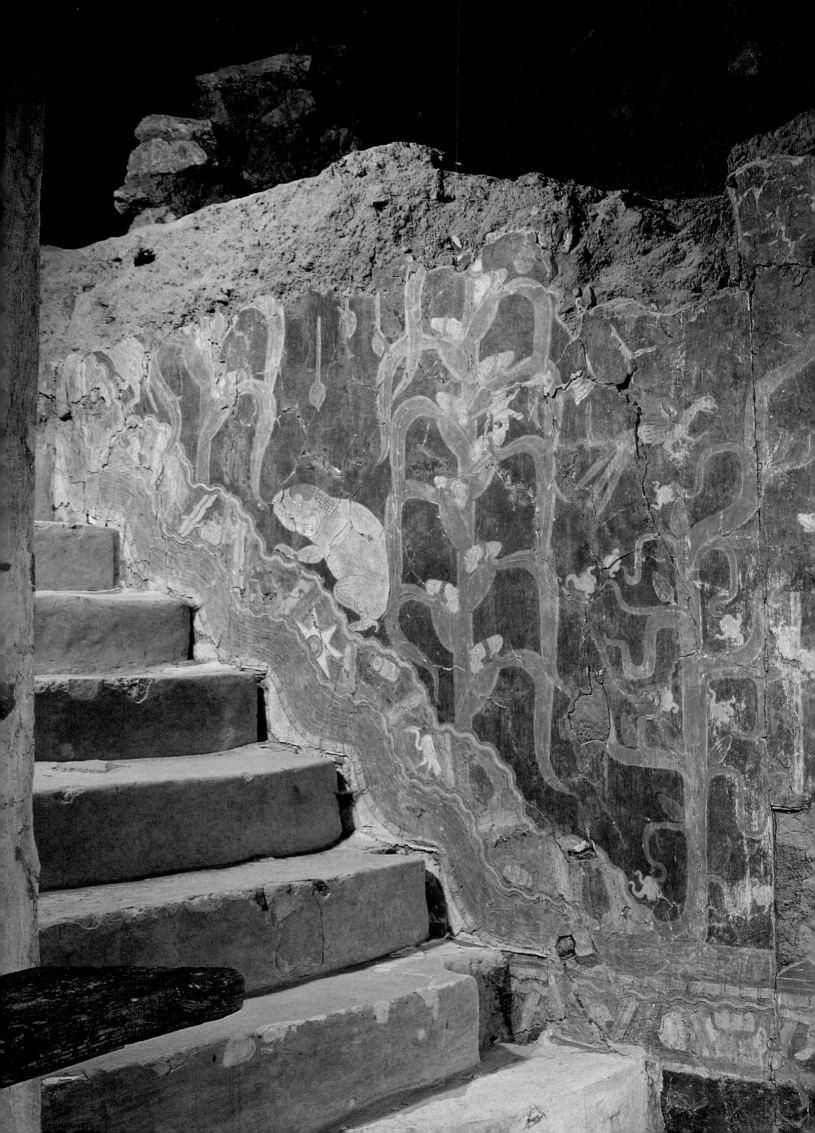

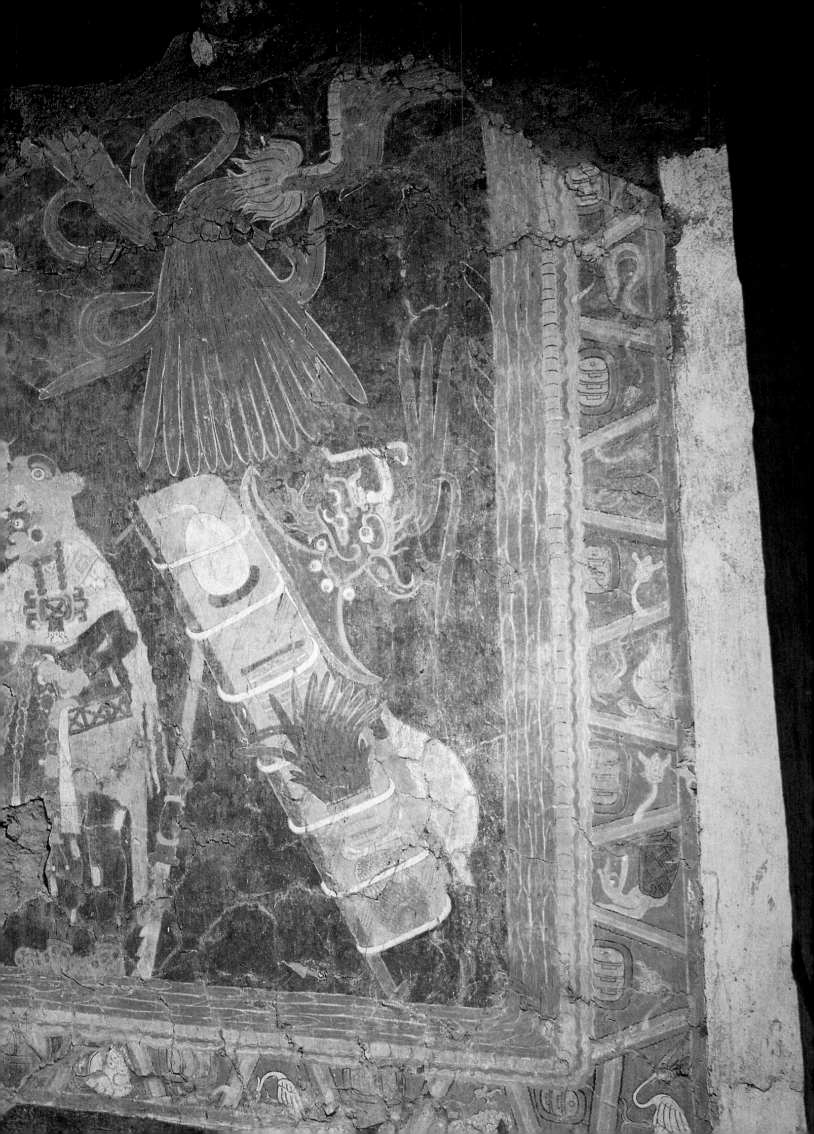

enemies the bird-warriors, whose mutilated and bloody remains lay strewn on the ground. Some, still alive, display their intestines, their facial ex-pressions distorted in a single scream of pain. It is terrible to lose, and the vision of the defeated always provokes horror and compassion. This was our landscape after the battle, the legacy of our ancestors, the rivalry among ethnic groups and the partial defeats before the immense final defeat that would some day come to us over the Atlantic Ocean.

Cacaxtla is a very young archaeological zone. It was only discovered in 1975, 12 miles from Tlaxcala. Its vibrant red murals amazed the visitors because of the wonderful preservation of the colors. They are framed by a blue strip decorated with water plants and animals, and under them the plumed serpent crawls on its yellow belly. Its feathers exhibit all the possible hues of blue, but turquoise stands out. And as if this were not enough, the ears of corn, a sacred food, are crowned with human heads.

How did the ocean ever make it to the high plateau? Did a Mayan painter come all the way from Yucatán to paint conches and turtles, only to laugh at the Tlaxcaltecs who had never seen salt water?

The history of Mexico starts with the founding of Mexico City in 1325 by the Náhuatl people coming from the distant north in search of the manifestation of their vision. They left a colorless land to discover the vividly colored high plateau. A black eagle rises above a green cactus while it shreds a snake in its beak. It is destroying evil. That is the clue: there the Aztecs must build their city, Tenochtitlan. The image is the emblem of our national flag. The colors are green, white, and red. The Aztecs, or Mexicans, the speakers of the Náhuatl language, had suffered before coming to the Valley of Mexico. Nobody knew who they were, nobody had seen them before, and everybody asked where they came from. They were nomadic warriors, considered barbaric. The settled peoples rejected them. The lord of Culhuacán told them they could camp out in a hostile site so full of snakes that they had to flee. They continued in their eternal pilgrimage until they found the place in the middle of Lake Texcoco that had been foreseen by their god of war Huitzilopochtli, just as it is told in the *Mexicayotl Chronicle*: they would find an islet where an eagle would be tearing a snake apart.

According to *Historia de los mexicanos por sus*

MEXICAN COLOR

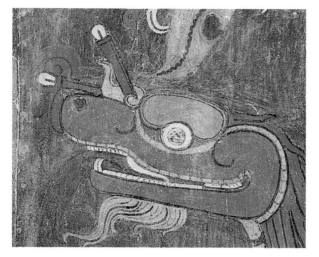

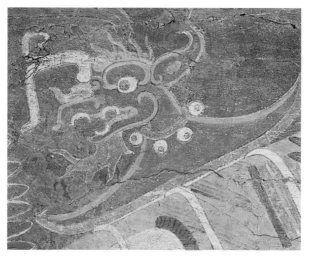

pinturas, cited by historian Enrique Florescano, the surface of the earth was divided by two crossed lines into four segments. The center, "the navel," was represented by a perforated green stone, on whose midpoint the four petals of a gigantic flower converged, a symbol of the map of the world. Each one of the cardinal points had been assigned a color. In the central highlands, the most common belief system associated black with the North, white with the West, blue with the South, and red with the East. Green belonged to the center, or "navel of the world." Among the many other symbols associated with the four directions are flint for North, house for West, rabbit for South, and cane for East, and these symbols in turn represented a double opposition life-death (inert matter versus extreme mobility) and male-female (sexual symbols contained in cane and house respectively).

No other people in the world has based an entire cosmogony on a theory of color. To exorcise chaos and establish order were the sacred goals of the cosmogonical myth. In the creation of the world there had been five suns that the ancient Mexicans set in motion with their jewels of jade and their tiger and jaguar pelts. These suns remained at the edge of the earth without giving off any color. ("Not to give off color" is a Mexican expression meaning the inability to define oneself, to take needed action.) Since the suns were not rising and setting, the gods Nanahuatzin and Tecuciztecatl resolved to make a supreme sacrifice: to throw themselves into a bonfire. The first god to do this was a god despised for his ugliness because he was covered with boils: Nanahuatzin, the disfigured god. The other had no recourse but to follow, throwing himself into the pyre. Their red blood would strengthen the sun. This is the origin of human sacrifice, and the blood that flows through our history, our paintings, our tradition, our everyday life. Blood is, therefore, a supreme offering, the blood and flesh that are also a part of the Christian Eucharist.

The maiden or youth on an altar of sacrifices faces the obsidian knife. With it, the high priest will open the breast to extract the bleeding heart and offer it to the sun. Many hearts! Amid pyramids of red hearts, the god devours hearts and drinks blood. If there are not enough hearts, they must make war and sacrifice the defeated.

The rise and fall of the previous suns has

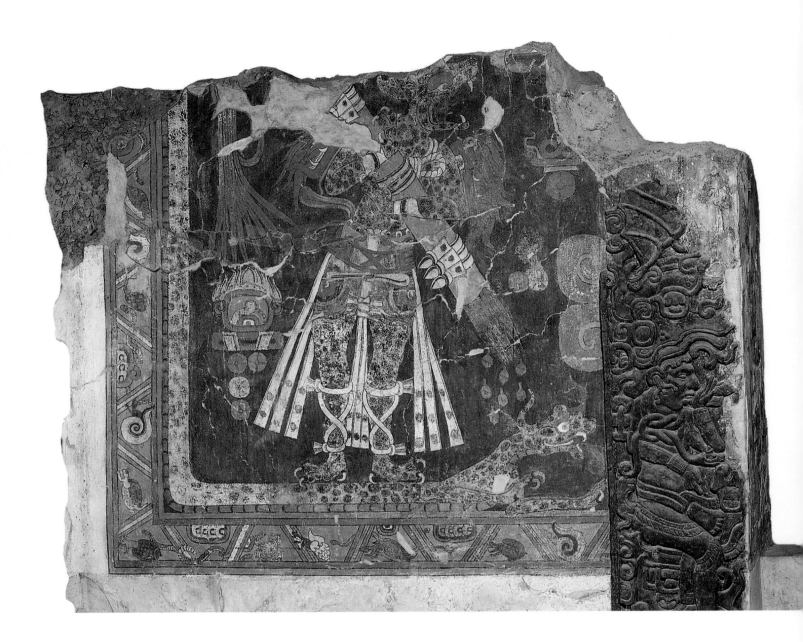

brought us to the fifth sun, and the persistence of a world that demands sacrifice. In order to give life to the world there is no other way but self-immolation. Blood is what allows the sun to live and shine again the next day. Without that blood, an eternal night would cover everything. Without blood we are drained white, there is no color. This is why the *tlacuilos* painted with blood. If other pigments can be made from minerals, red must come from blood.

In those days, red flowed in five different tones, even when time had faded all five into one.

The codexes tell the history of the ancient Mexicans with colors by means of a pictographic language, ideograms that register events. They tell of the works, days, and years of the ancient Mexicans, and most of all, their comings and goings, through the use of symbols. Oh! How far their bare feet walked! Many black footprints of

ABOVE: *Cacaxtla, Tlaxcala.* Jaguar Warrior is a symbol of royal power. Blood, meaning life, was very sacred to the Cacaxtlans. It is a symbol of fertility and water. These two murals stand side by side.

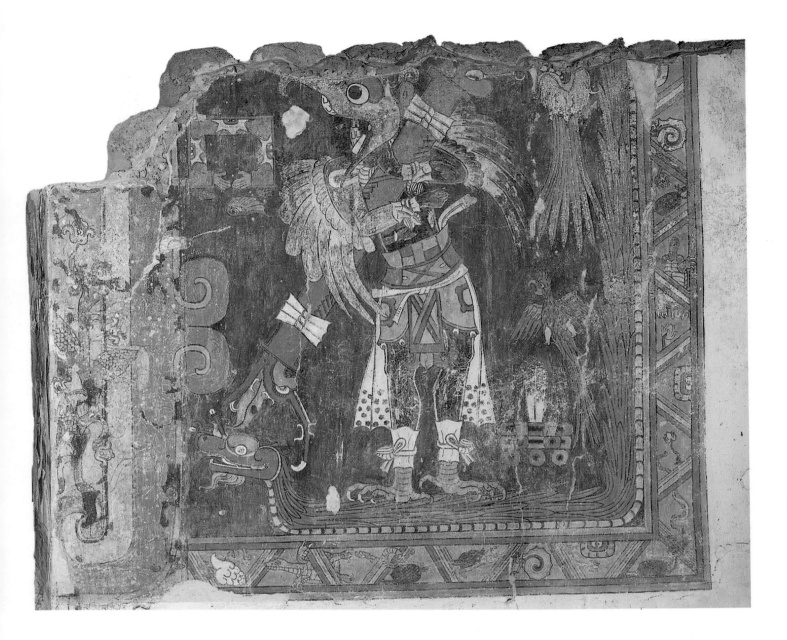

small feet traverse the codexes. Only the priests understand this writing: the people have no access to its meaning.

Bernal Díaz del Castillo, in *The Discovery and Conquest of Mexico,* sees Tenochtitlan as a mirage on the liquid horizon, a populated island on a mirror of blue water: "We were amazed and said that it was like the enchantments they tell of in the legend of Amadis on account of the great towers and cues and buildings rising from the water...seeing things as we did that had never been heard of or seen before, not even dreamed about. I was never tired of looking at the diversity of the trees, and noting the scent that each one had, and the paths full of roses and flowers, and the many fruit trees and native roses, and the pond of fresh water. There was another thing to observe, that great canoes were able to pass into the garden from the

ABOVE: *Cacaxtla, Tlaxcala.* Bird Man. The first mural unearthed in Cacaxtla in 1975. It is believed that the murals of Cacaxtla were buried intentionally. This is obvious, because a layer of protective sand was placed between the murals and the fill. Cacaxtla was abandoned, and great care was taken in preserving the murals for their later discovery.

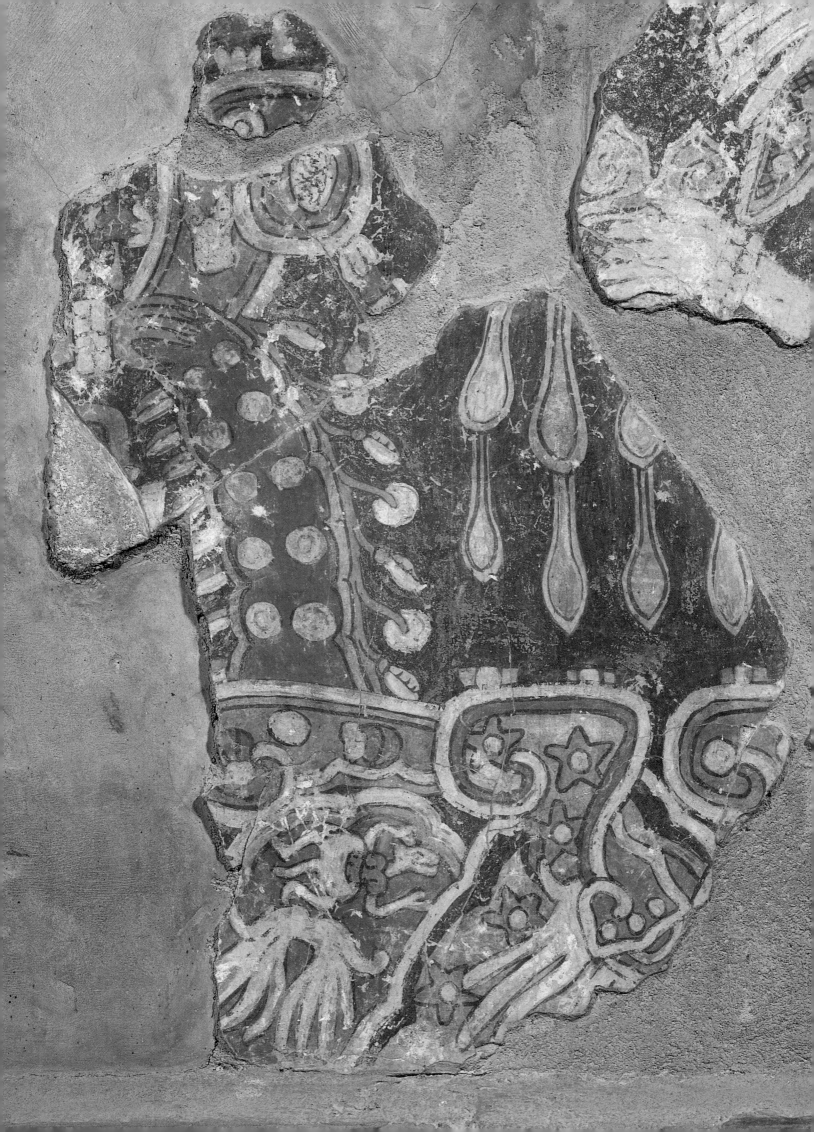

"We have found buildings made out of silver. They were only painted white, but they reflected light in such a way that they looked metallic."

—Bernal Diaz de Castillo

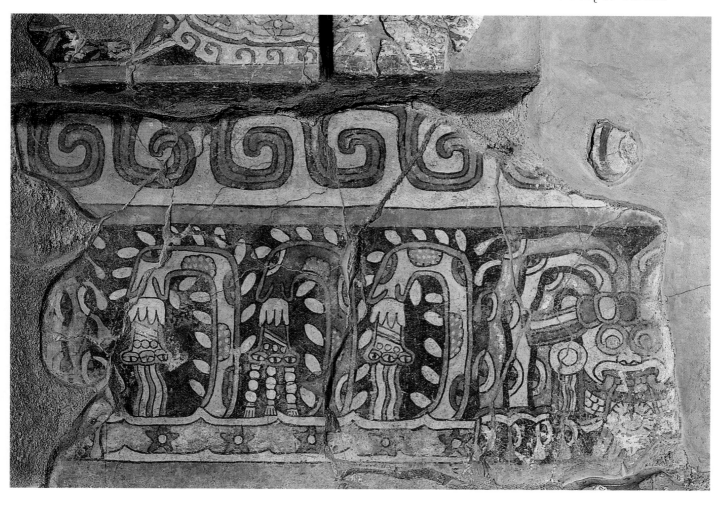

lake through an opening that had been made so that there was no need for their occupants to land. And all was cemented and very splendid with many kinds of stone monuments with pictures on them, which gave much to think about. Then the birds of many kinds and breeds came into the pond."

Originally Tenochtitlan was white with a red stripe at its base. The pyramids were white, and the fascinated Spaniards went back to Cortés and told

him, "We have found buildings made out of silver. They were only painted white, but they reflected light in such a way that they looked metallic."

Today, the pyramids have lost their coat of color, but there was a day when no engraved stone was left unpainted. This diversity of colors and materials was not reserved for buildings: Bernal Díaz del Castillo wrote of the "Great Montezuma

LEFT: *Teotihuacán.* Tepantitla Tlalocan. Detail of rain and the planting of seeds. The flower symbols are to stimulate fertility and growth. Classical period, 100 B.C.–A.D. 700. ABOVE: *Teotihuacán.* Tepantitla Tlalocan. Detail of border that includes the head of a snake. Classical period, 100 B.C.–A.D. 700.

"I have seen the things that were sent to the King from the golden lands. They are a wonder to the eyesight. Never in my life have I seen things that fill me with more happiness."

—Albrecht Dürer

[who] got down from his litters, and those great Caciques supported him with their arms beneath a marvelously rich canopy of green colored feathers with much gold and silver embroidery and with pearls and *chalchihuites* suspended from a sort of bordering, which was wonderful to look at."

Maybe these ornaments, so coveted by the Spaniards, have something to do with the shameless, carefree, and sovereign way we Mexicans paint our houses.

In 1520, by means of the Flemish court of Charles V, the first samples of merchandise from the New World made their way to Brussels. There the German engraver Albrecht Dürer wrote in his *Diary of a Journey to the Netherlands*: "I have seen the things that were sent to the King from the golden lands. They are a wonder to the eyesight. Never in my life have I seen things that fill me with more happiness."

And in the words of Alfonso Reyes, in *Vision de*

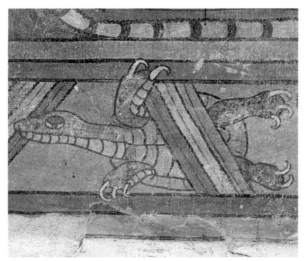

Anahuac: "The people dress with brilliance, because they are before a great emperor. Cotton tunics come and go: red ones, golden ones, some heavily embroidered, others in black and white, ornamented with circles of feathers or painted figures. The imperturbable brown faces smile and aim to please. Heavy gold rings tremble in the earlobes or noses. Throats are covered with eight rounds of necklaces, multicolored stones, jingle bells, and gold pendants. Feathers swing over the black smooth hair as people walk. Muscular legs sport metallic hoops and shin guards of silver leaf with yellow and white leather deer hide. The flexible sandals squeak. Some men wear big shoes made out of sable-like material and a white sole sewn with golden thread. In people's hands the ornate flyswatter flaps its wings, or a staff in the shape of a coiled snake is held, with its mother-of-pearl teeth and eyes, and a knob

ABOVE, CENTER AND BELOW: *Cacaxtla, Tlaxcala.* Border details in the Red Temple. Aquatic animals suggest a voyage to the Gulf Coast. RIGHT: *Cacaxtla, Tlaxcala.* Corn plant.

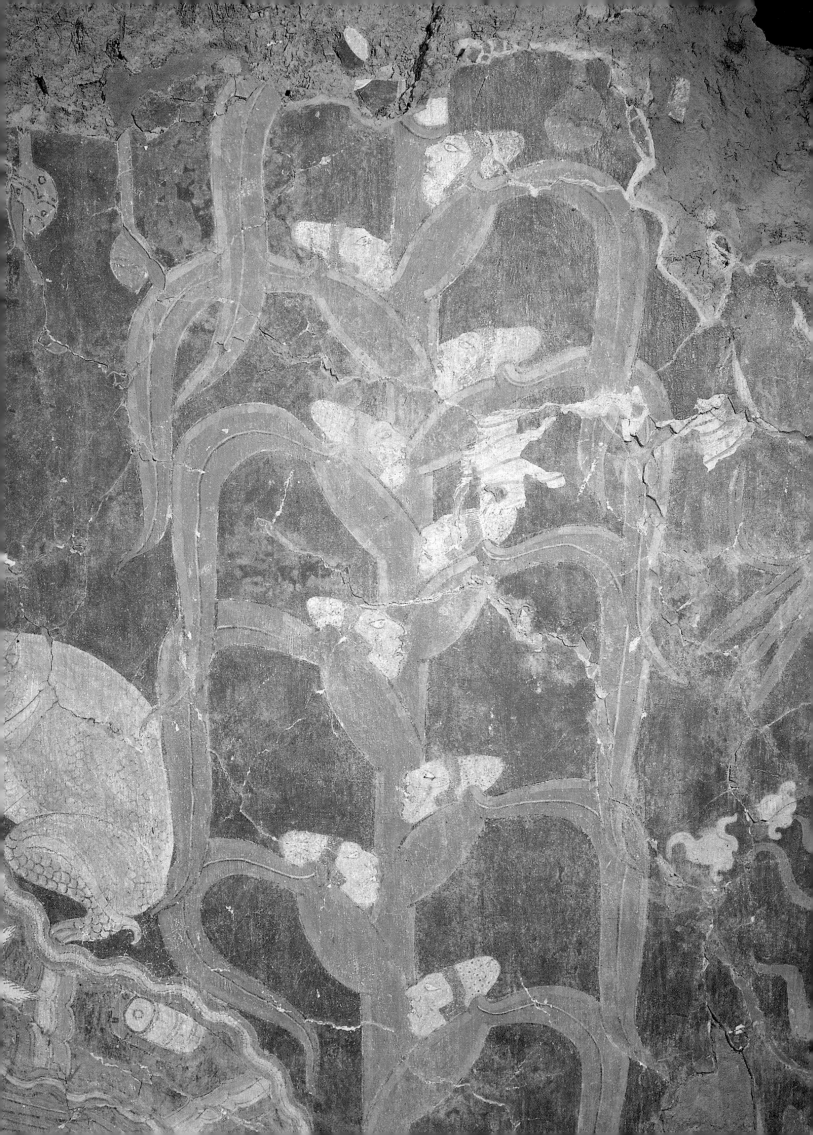

made out of engraved leather and feathers. Leather, stones, metals, feathers, and cotton fuse their pigmentation in an incessant iridescence, communicating to men who look like delicate toys in their quality and fineness.

"The life of the city is centered around three spaces, as happens in any normal town. One is the house of the gods, the other is the market, and the third one is the emperor's palace."

The market, *tianguis* in Náhuatl, still appears in each neighborhood with its fuchsia awnings. Hernán Cortés, full of admiration, described it for the kings of Spain: "The city has many open squares in which markets are continuously held. One square in particular is twice as big as that of Salamanca and completely surrounded by arcades where there are daily more than sixty thousand folk buying and selling. Every kind of merchandise such as may be met with in every land is for sale there, whether of food and victuals, or ornaments of gold and silver, or lead, brass, copper, tin, precious stones, bones, shells, snails, and feathers: limestone for building is likewise sold there, stone both rough and polished, bricks burnt and unburnt, wood of all kinds and in all stages of preparation. There is a street of game where they sell all manner of birds that are to be found in their country, including hens, partridges, quails, wild duck, fly-

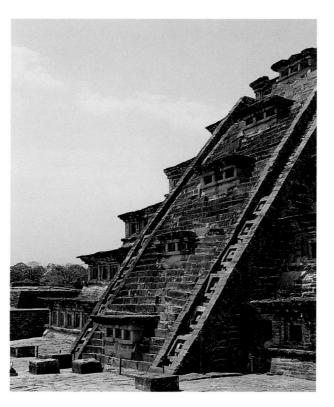

catchers, widgeon, turtle doves, pigeons, little birds in round nests made of grass, parrots, owls, eagles, vulcans, sparrow-hawks, and kestrels; and of some of these birds of prey they sell the skins complete with feathers, head, bill, and claws. All kinds of vegetables may be found there, in particular onions, leeks, garlic, cresses, watercress, borage, sorrel, artichokes, and golden thistles. There are many different sorts of fruits, including cherries and plums very similar to those found in Spain. All kinds of cotton thread in various colors may be bought in skeins, very much in the same way as in the great silk exchange of Granada, except that the quantities are far less. They have colors for paint of as good quality as any in Spain, and of as pure shades as may be found anywhere. There are leathers of deer both skinned and in their natural state, and either bleached or dyed in various colors. A great deal of chinaware is sold of very good quality, including earthen jars of all sizes for holding liquids, pitchers, pots, tiles, and an infinite variety of earthenware—all made of very special clay and almost all decorated and painted in some way. There is nothing to be found in all the land that is not sold in these markets, for over and above what I have mentioned there are so many and such various other things that on account of their very number and the fact that I do not know

ABOVE: *El Tajín, Veracruz.*

their names, I cannot now detail them."

Separating pre-Cortesian arts from handicrafts is not easy. Peasants— men, women, and children—one day began to weave, and with their earthen hands, they spun and combed wool without any pretense. It was necessary to make blankets to cover oneself at night, cloaks to protect one's body from the cold, and then jugs to carry the water in, or stools to sit on. In the act of molding clay or carving wood, they never thought they were doing anything artistic, nor did the maker of fireworks think that his sparkling wheels of fortune spinning in the night could last for more than one "hap-

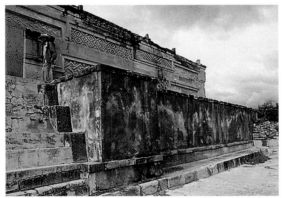

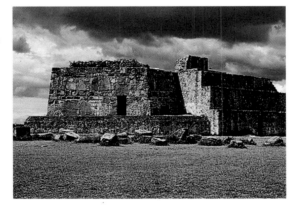

pening." The young shepherd who carves a piece of wood while he watches over his sheep; the glassman who blows a bubble through his pipe and then shapes a round red pitcher or a green drinking glass in Carretones, the baker who decorates his bread of the dead, do they think that they are creating art? Just like the 13th century builders of Chartres who did not know they were constructing one of the most beautiful vessels of the Middle Ages, Mexican hod carriers (*tamemes*) and masons in Teotihuacán humbly took up their hammers to

pound the quarry and then carried block after block to create the Pyramid of the Sun. They painted every stone one by one. No sculpture, no figure lacked color. Outside, the celestial powers that we call elements have ravaged the paint, while frescoes have been better preserved indoors. The Conquerors ordered the destruction not only of the city of Tenochtitlan, but of all pre-Columbian art. They supplanted the gods of rain, fertility, and war with a single god who did not only fail to exercise his powers, but managed to be executed on a cross like any old poor thing. The Conquerors profaned tombs and pillaged offerings. They stole gold and shattered pottery to smithereens. They desecrated the altars of the ancient gods and burned the codexes. For the Mexicans of the 16th century, the Conquest was catastrophic, the worst of all cataclysms, the death of their civilization, the greatest civilization of early America. Neither heaven nor earth would ever be the same after the arrival of those white men, straddling huge "deer" and bringing with them a marvelous invention to the new continent: the wheel.

ABOVE: *Tulum, Quintana Roo.* CENTER: *Mitla, Oaxaca.* BELOW: *Monte Alban, Oaxaca.*

CHAPTER TWO

People of the Sun

In Tonantzintla, indigenous people paint themselves as innocent angels bound for paradise...

THE COLONY TOOK ADVANTAGE of the pre-European past. Pagan qualities seep through any religious feast. Tonantzin, our little mother, becomes the Virgin of Charity in Tlaxcala and the Virgin of Guadalupe in the whole country, both of them having come from Spain. Friars Christianized the old goddesses, and took advantage of their cult to superimpose on them the sweet, insipid, and inane saints and martyrs of

LEFT: *San Cristóbal de las Casas, Chiapas.* Church of Guadalupe de San Cristóbal de las Casas. The entrance has 285 steps leading to it. ABOVE: *Erongaricuaro, Michoacán.* Flowers at the entrance of the cemetery during Day of the Dead.

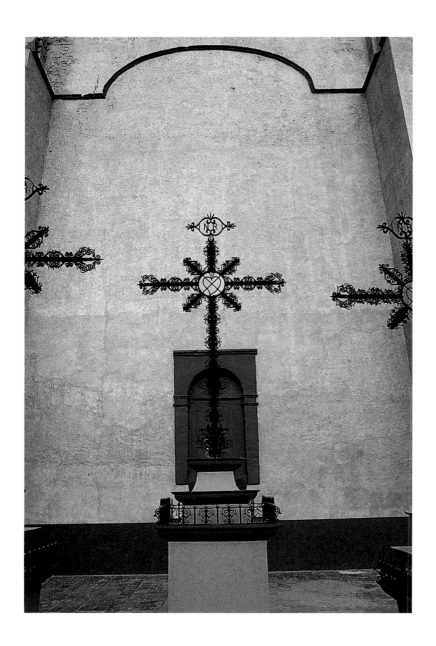

martyrs of the other side of the Atlantic.

In the feast of Xochiquetzal, the goddess of flowers, the priestesses and virgins threw petals of all colors on the ground, and created carpets of flowers and sawdust, ephemeral rugs more luxurious than those of ancient Persia because their colors were capable of intoxicating. Huamantla, 28 miles from Tlaxcala, was a scandal of colors, a rescue from anonymity, a high yellow scream to repulse the Conquerors, a consecration from here to eternity. In the eyes of the world, we were the people of the sun, the children of the builders of pyramids, the astronomers of El Caracol, the makers of the calendar, the great givers—those who were giving back to the old continent its lost paradise, because if there ever was a site on earth that could have been called Paradise, it was precisely in America.

ABOVE: *Tlaxcala City.* Cathedral, formerly Parroquia de San José. Started in the 16th century, modified in the 17th, 18th, and 19th centuries. The church has a baroque facade and tiled dome. RIGHT: *San Cristóbal de las Casas, Chiapas.* Situated on the Plaza 31 de Marzo is the Cathedral. In the style of the 16th-century early baroque. The columns are Corinthian, created in 1528.

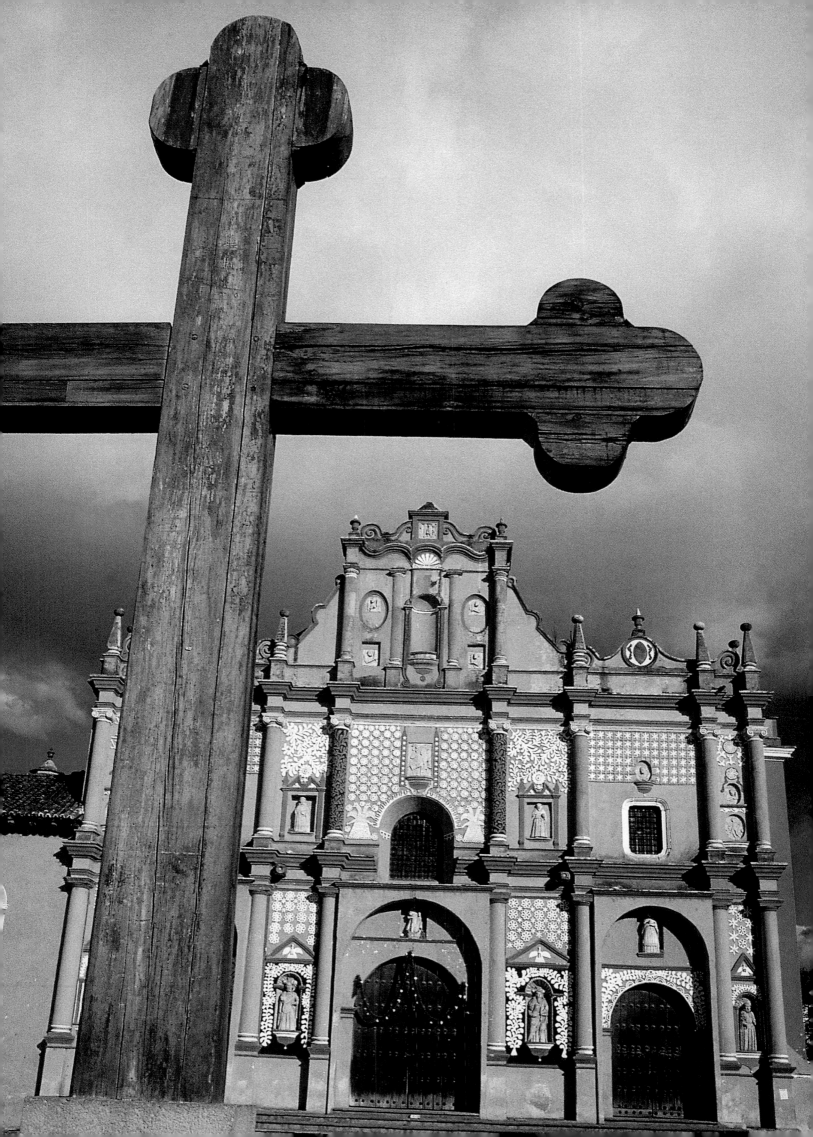

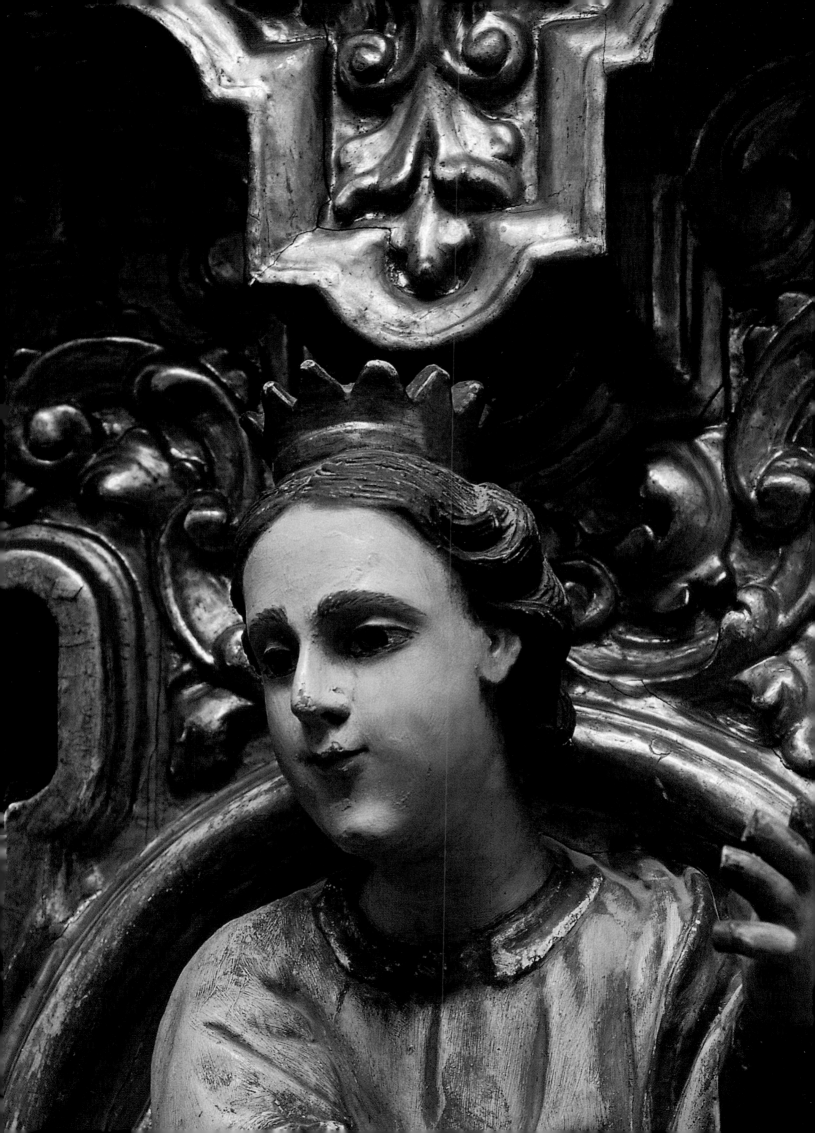

"No one was more sensuous than Xochi-quetzal, visited by the gods in the cave where she, the red one, lay next to Pilzintecutli, son of the first human couple. From their union, Centeotl, 'the young god of corn,' was born; he who hid under the earth, from whose hair cotton sprouted, from whose ear a wonderful seed called *huazontil* came, which they ate happily; from whose other ear came another seed, and from whose nose one more seed came which they called *chian*, good for making a summertime drink; from whose fingers a fruit called *camotli* sprang, something like turnip, a good product; from whose fingernails came a kind of long corn cob, which is the one they eat to date, and from the rest of whose body many other fruits came which are planted and harvested by the people." This one can read in *Histoire du Méchique*.

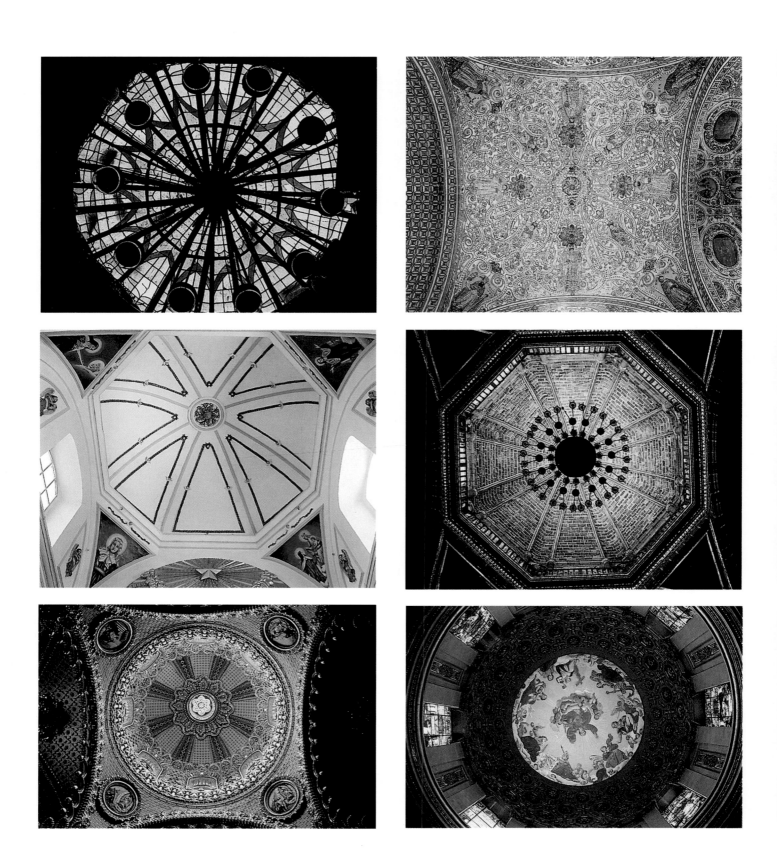

ABOVE LEFT: *Morelia, Michoacán.* CENTER LEFT: *Oaxaca.* Church. BELOW LEFT: *Mexico City.* Kiosk in Coyoacán Plaza. ABOVE RIGHT: *Oaxaca City.* Santo Domingo Church interior, late 17th century plasterwork. CENTER RIGHT: *Morelia, Michoacán.* Dome, San Diego Church. The 18th century decoration is made from fired and painted clay. The motifs are of plants and geometric shapes. BELOW RIGHT: *Mexico City.* Convent. RIGHT AND FOLLOWING PAGE: *San Cristóbal de las Casas, Chiapas.*

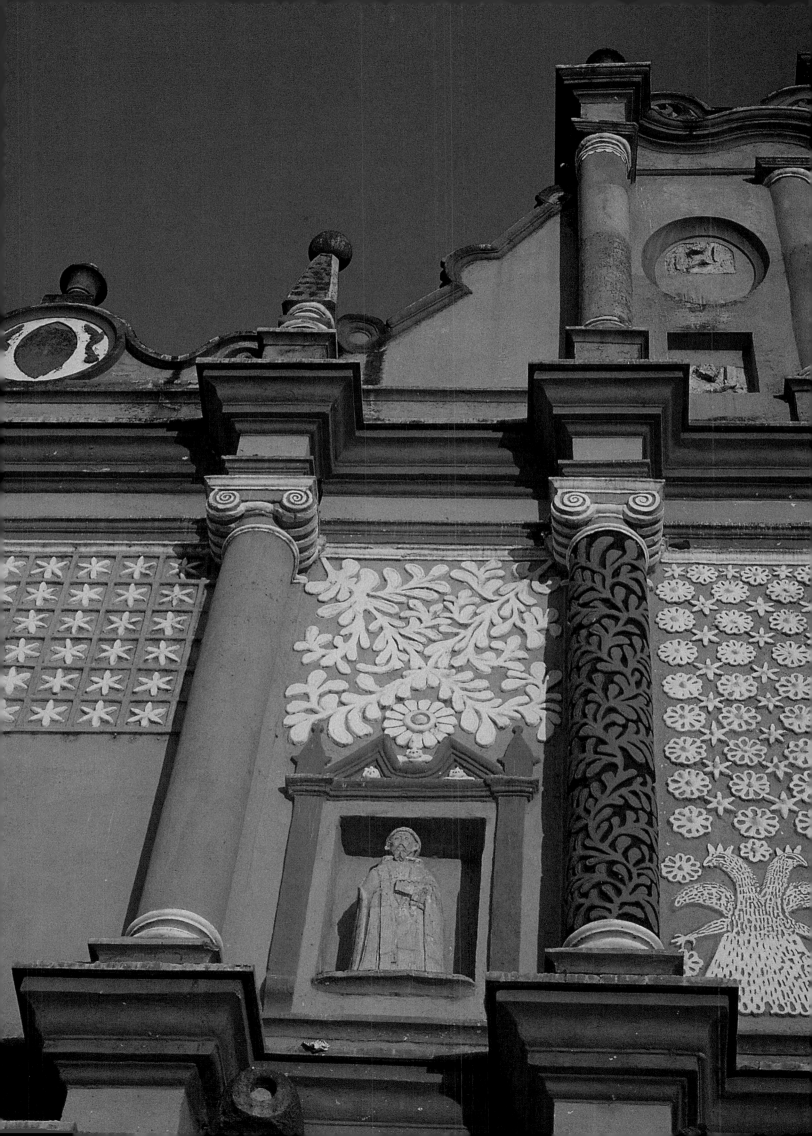

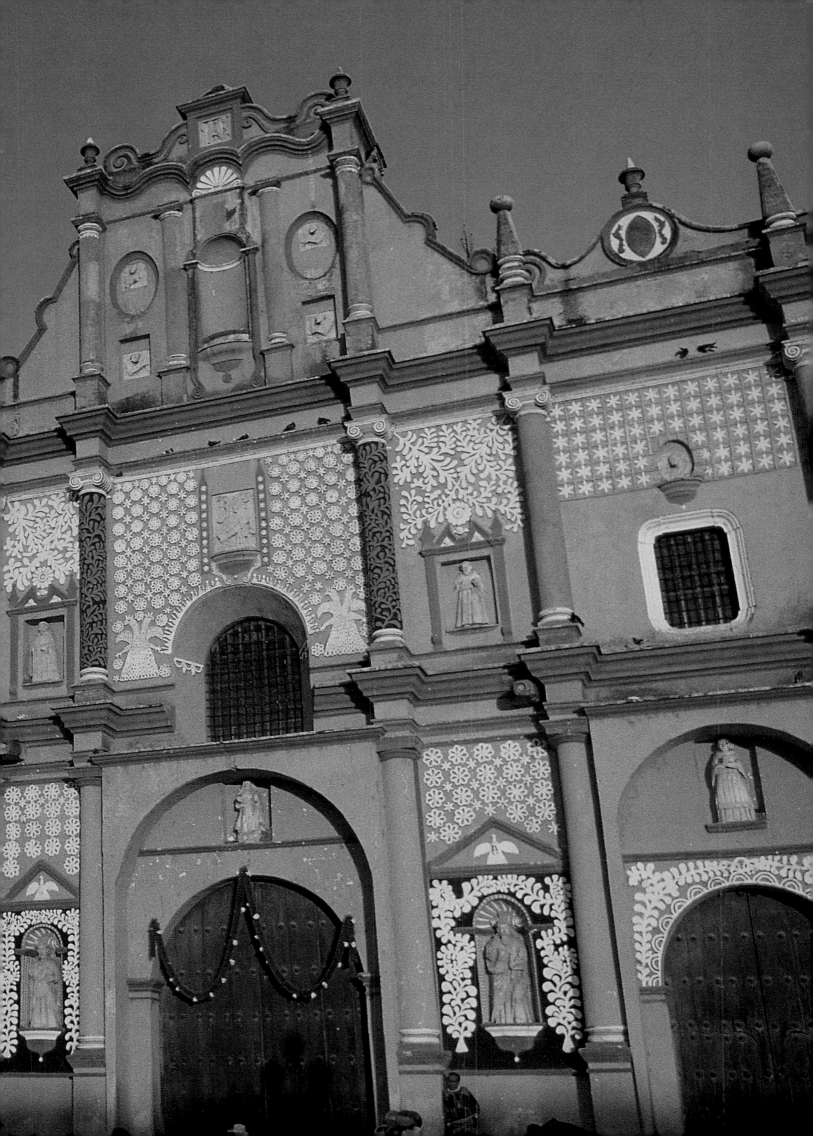

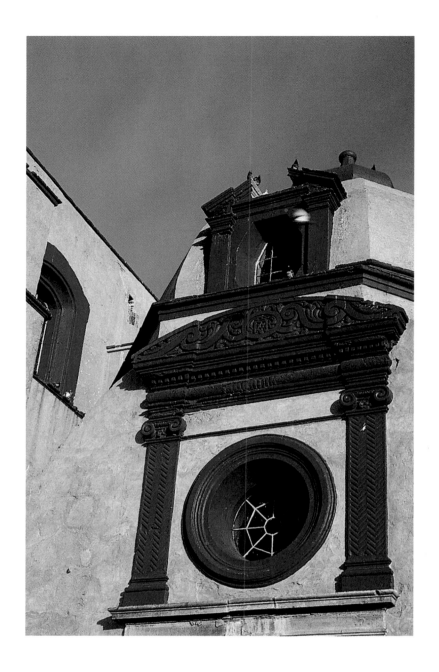

The history of the Conquest in the eyes of the vanquished, *Broken Spears: the Aztec Account of the Conquest of Mexico*; says that the Náhuatl father was a tender man who addressed his daughters as "feathers of quetzal," "necklaces of fine stones," "beads of jade." He warned them against a world full of calamities. He told them that if they did not sweep and scrub their homes and their interior courtyards, he would punish them by piercing their fingers and hands with the thorns of the *maguey* or by making them breathe the smoke of roasting chilies. He told them they should not go around in the market looking for any man, but should a young and honest man present himself to them, they should not despise him, even if he were only a humble tiger-knight. The girls had to use the seven colors and other colors of their own invention in their weaving.

ABOVE: *Tlaxcala, City*. Detail, Parroquia de San José. 16th century.

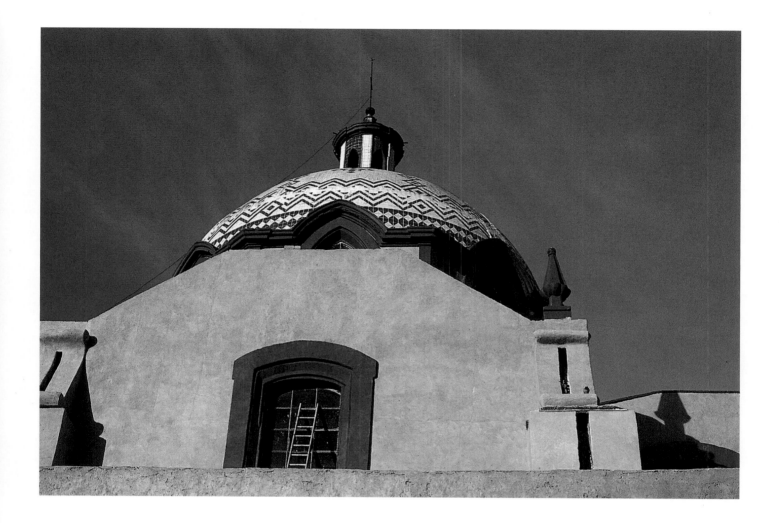

The Náhuatl father also cautioned them against the evil woman dressed in red who exhibits herself in the marketplace and whom José Clemente Orozco many years later would paint lying on the floor with the great hot laughter of a prostitute.

Huamantla is delicate and secret. One has to know how to hold her by the waist, ask her to dance, walk her to mass, brush her hair, offer her a lace mantilla for her head, put a bouquet of

dahlias in her hands. The young ladies of Huamantla hold eternity in the point of their needles. They will thread them in white, drive them into their embroideries, take them out again, and offer a cloth to the Virgin, a cloth sewn with their souls: that is the joy of the most virtuous Tlaxcalan women.

A small handful of fine sand, another one of sawdust, a cascade of petals, fresh moss, hay, wild

ABOVE: *Tlaxcala City.* Dome, Parroquia de San José. 16th century. OVERLEAF: *Tlaxcala City.* Parroquia de San José. 16th century, with the Chapel of San José to the right.

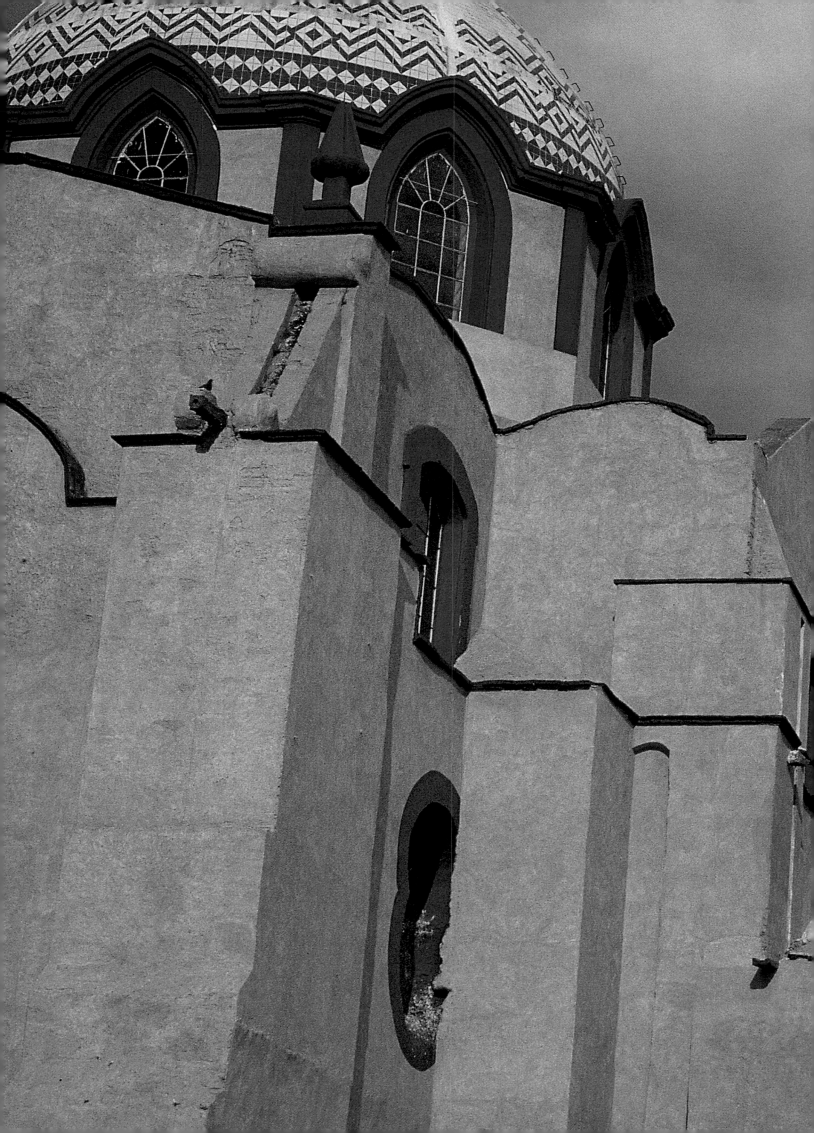

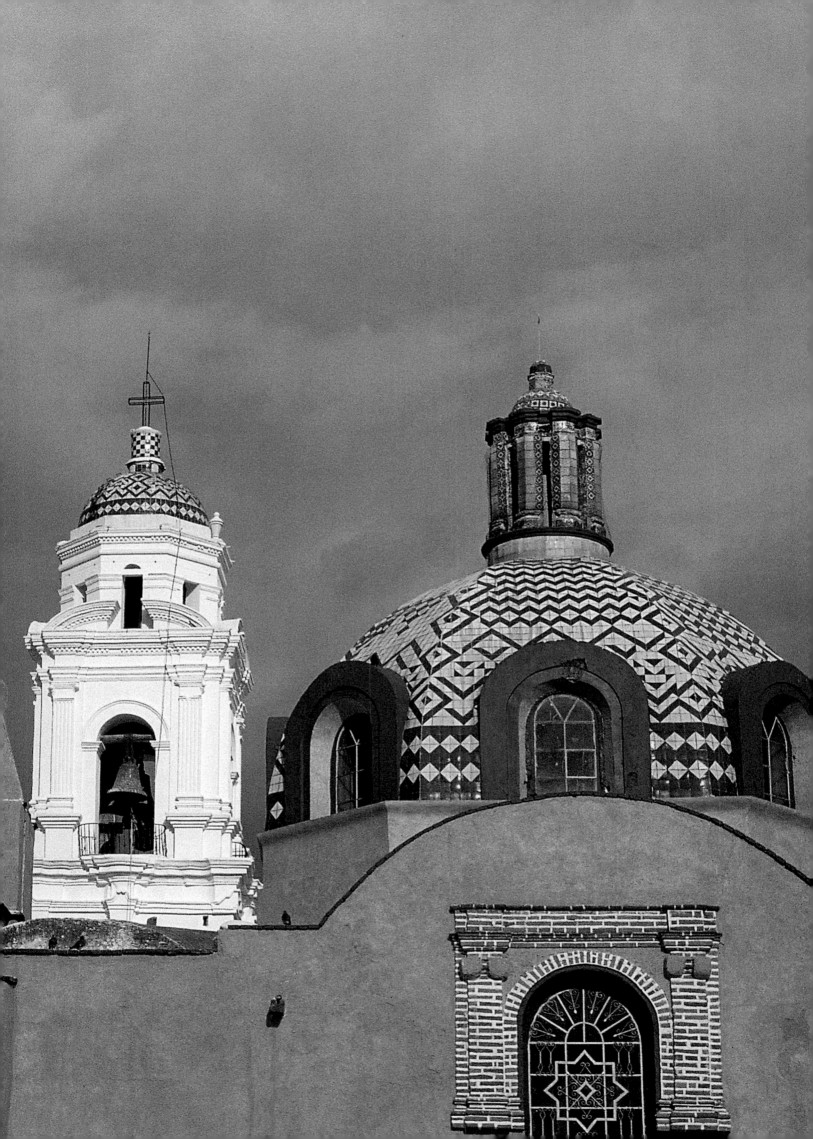

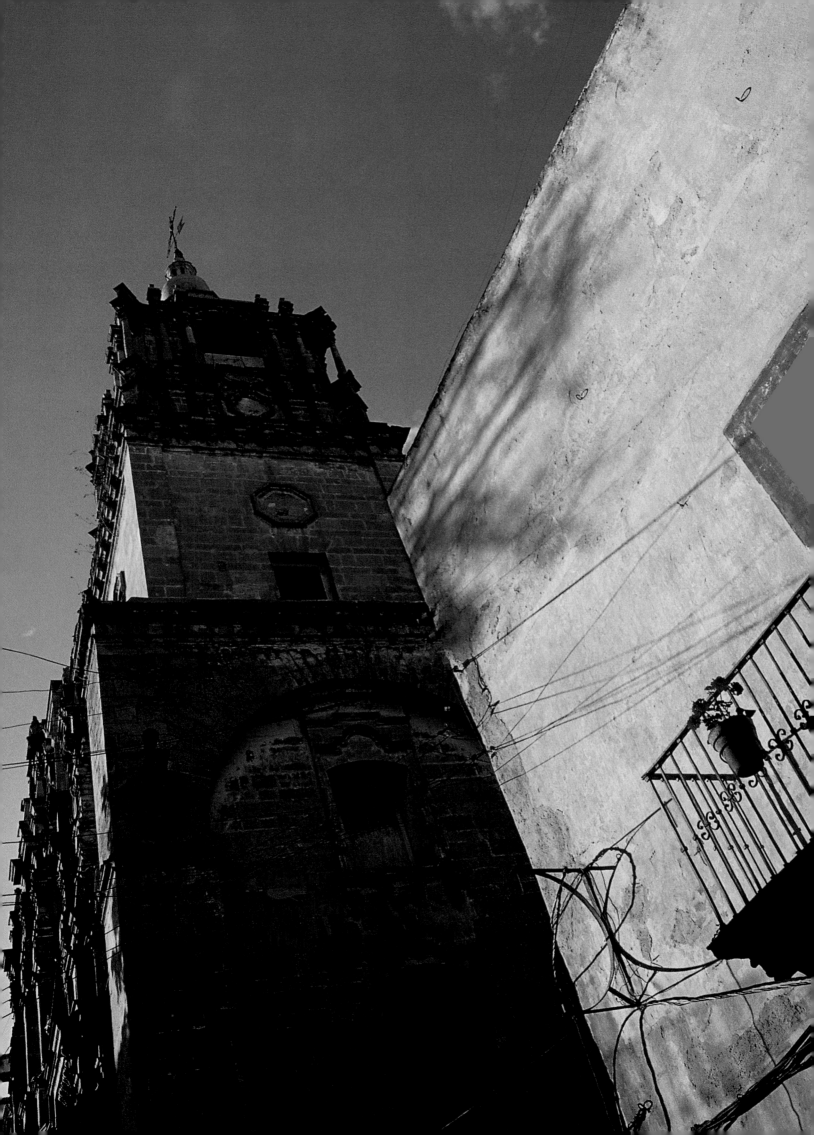

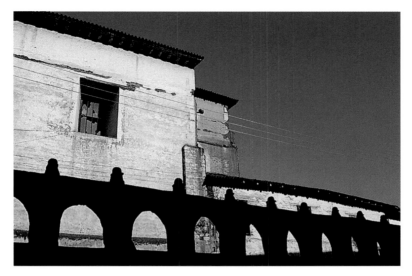

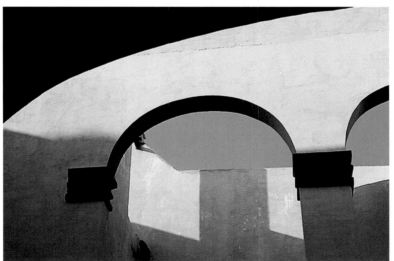

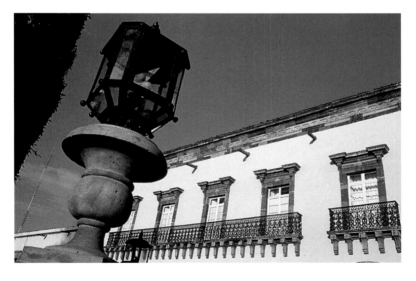

roses plucked from the side of the mountain they call Malinche, brought in baskets that women fret over all night, making sure each flower retains its fresh demeanor: these are the ingredients in the making of a carpet. They will cast the white petals of the chrysanthemum, the red ones of dahlias, the yellow ones of big sunflowers. The sparkle of silver and gold glitter framing the carpet will give it the ambience of a postcard or an ancient waltz, even when the music vibrating in the air is rock and roll. Ah! They should play instead the waltz composed by poet Miguel N. Lira, whose portrait Frida Kahlo painted.

In Huamantla, they plant all the flowers they will need for the festival in advance. On the very day, or perhaps on the eve of that day, women go out to the fields to cut roses, daisies, marguerites, butterfly-flowers, tiger-flowers, bird-flowers, dog-flowers, sunflowers, snail-flowers, red and purple flowers, the flower of the heart, white flowers, hand-flowers, *jilote* flowers, wild roses, rosettes, and gladioli. Women bring back thousands of scarlet flowers, and so many others in pale yellow, opal yellow, lemon yellow, egg-yolk yellow, blue flowers coming and

LEFT: *Guanajuato City.* Templo de la Campañía. 17th century Churrigueresque jewel. Finished in 1765 by José Sardaneta and Legazpi. It features a noble pink facade and a 19th century cupola. ABOVE: *Patzcuaro, Michoacán.* Casa de los Once Patios, convent of the Dominican Nuns from the 17th century. The convent originally had eleven patios. CENTER: *San Miguel de Allende, Guanajuato.* Interior of an artisan's shop. BELOW: *San Miguel de Allende, Guanajuato.* Zócalo.

going, purple-blue and pale blue, dark green, tender green, and green-envy from seeing so many beautiful blossoms, each one with its own hue, cut with utmost care, water delicately sprinkled over them. "Watch it, Gudelia! Don't let them wilt on you!" The petals are not plucked until the last minute, although some blossoms remain whole, facing the sun, with their stems—called "sticks" by the children—removed. Since there are no gar-

denias in Huamantla, thousands of white gardenias with pink and lilac touches arrive by truck from Fortín de las Flores. In some years they have bought more than twenty-five thousand gardenias, perfuming the air. At last, Huamantla, in the navel of Mexico, is crossed by a great avenue, a tapestry laid on the ground with the most submissive flowers on the planet.

How I would love to see one of those car-

ABOVE: *Guanajuato City. Plaza de la Paz.* Stucco details above windows in the evening sun. RIGHT: *San Cristóbal de las Casas, Chiapas.*

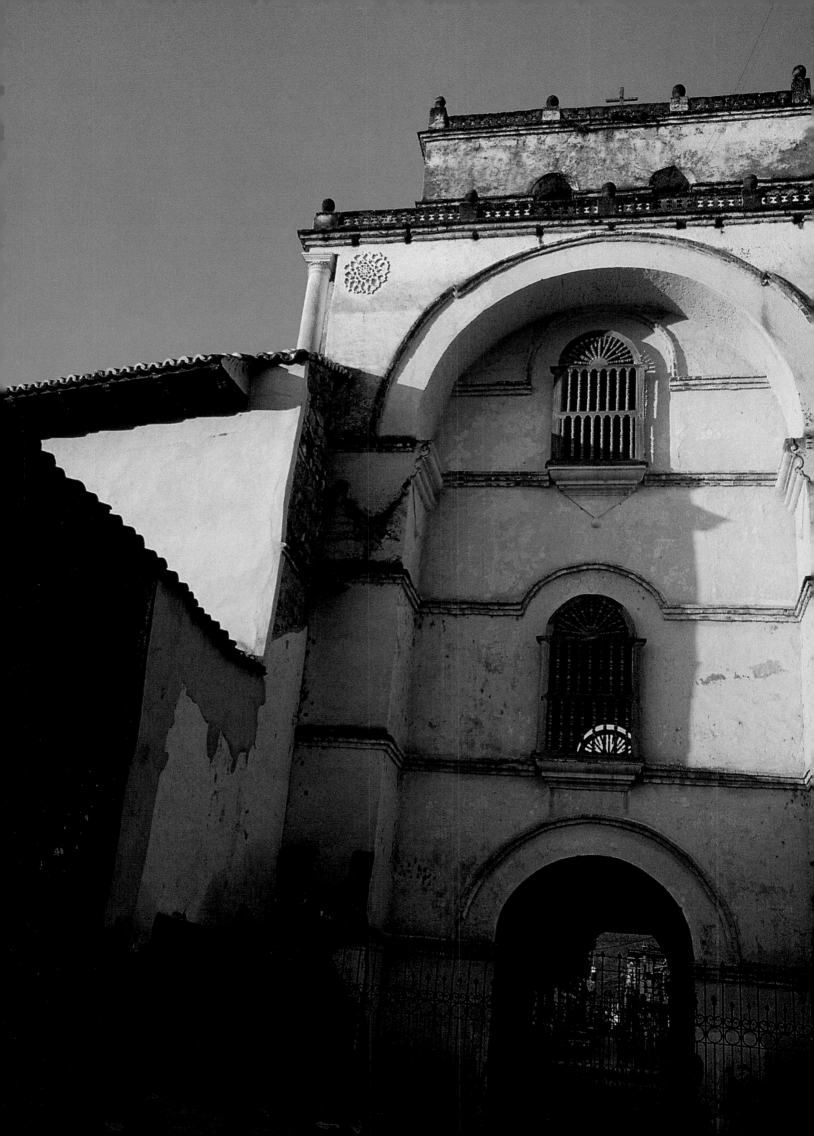

pets liberating itself in the middle of the day, snatching its flowers, flying in the air, soaring in the sky among the clouds!

Across the years and even today, color overflows the churches on the day of the feast of their patron saint. "Each chapel will sooner or later have its own little feast," the saying goes. Shiny satin ribbons of every color adorn the candelabra and the necks of saints. The Virgin sports a new dress embroidered with precious stones of a thousand colors, made by the most virtuous young ladies in Huamantla and all of Tlaxcala. Pink,

ABOVE LEFT: *Tlaxcala City*. Chapel San José, 16th century. ABOVE CENTER: *Tlaxcala City*. Plaza de la Constitución, 17th century. ABOVE RIGHT: *Chiapas*. San Cristóbal de las Casas, Church of Guadalupe de San Cristóbal de las Casas. BELOW LEFT: *Tlaxcala City*. Plaza de la Constitución. BELOW CENTER: *Tlaxcala City*. Palacio de la Justicia. Built in the 16th century as the Capilla Real de Indias in honor of the Tlaxcala warriors who fought with Cortez against the Aztecs. BELOW RIGHT: *Tlaxcala City*. Plaza de la Constitución. RIGHT: *Oaxaca City*. Contemporary Museum. Known as Casa de Cortez.

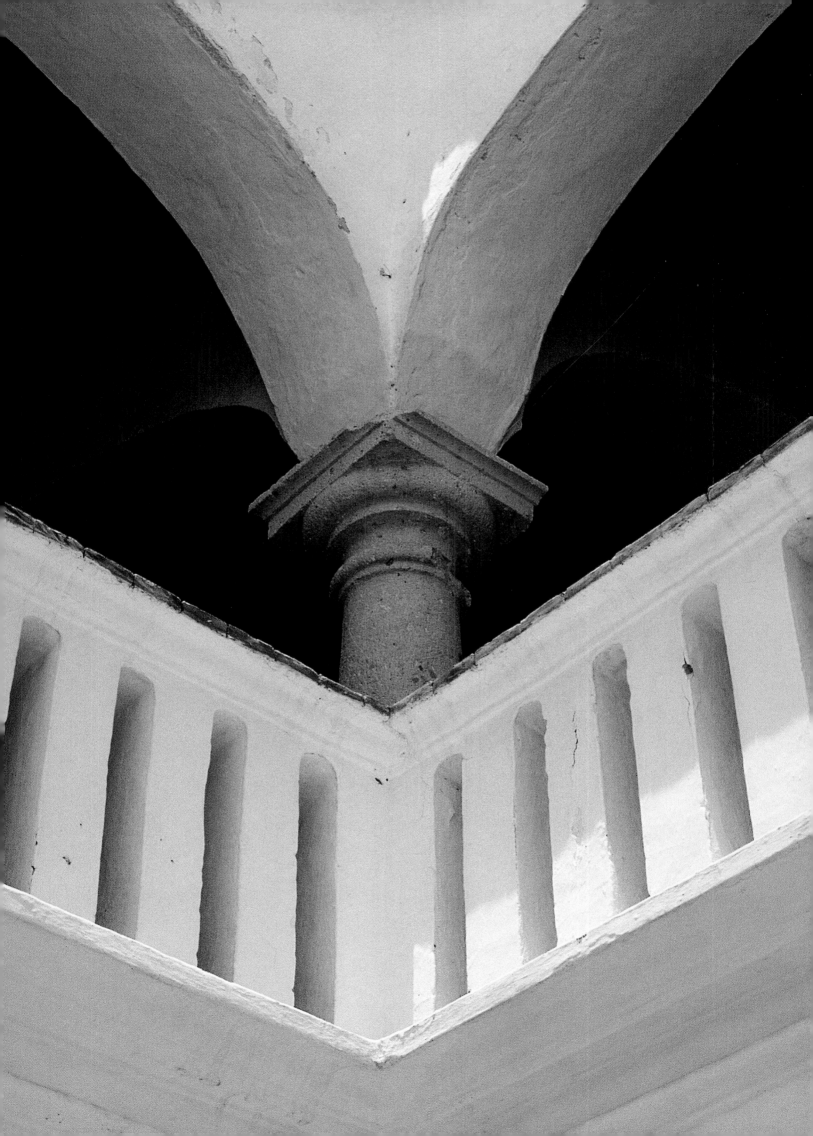

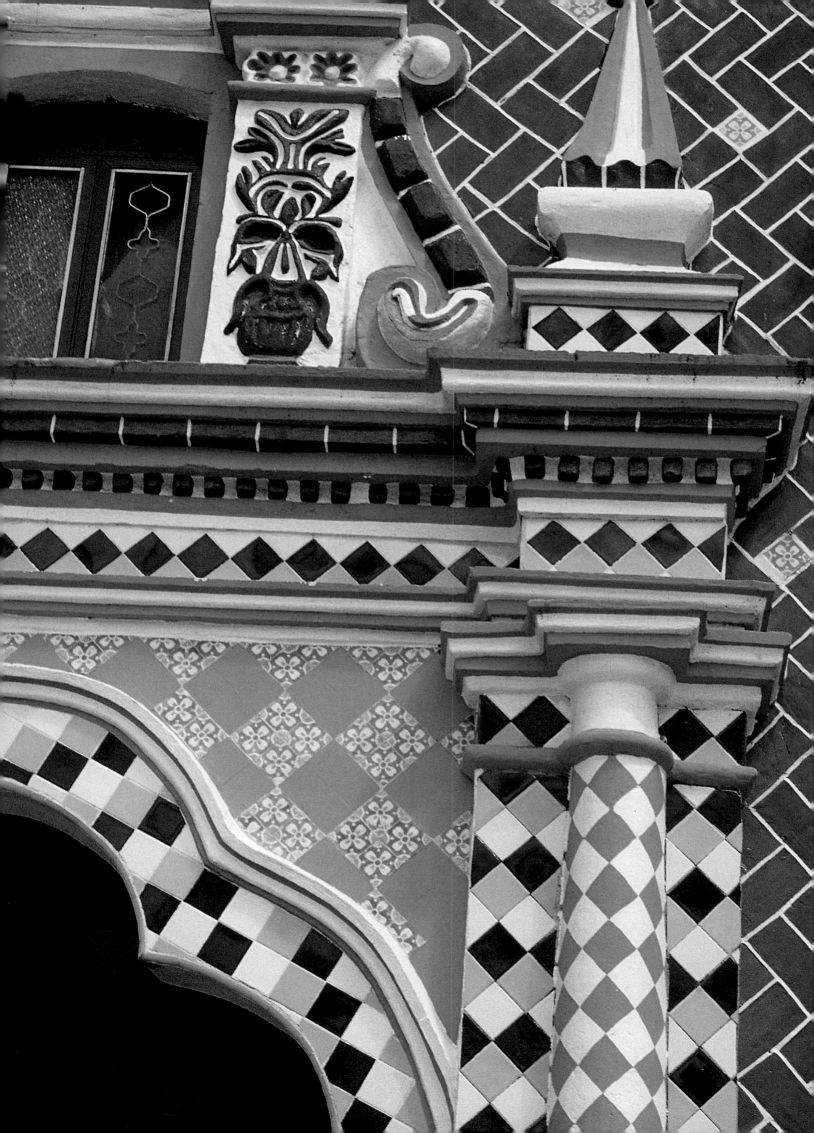

...the gods breathe menacingly under the earth, and when one least expects it,
they break through the surface to claim their powers.

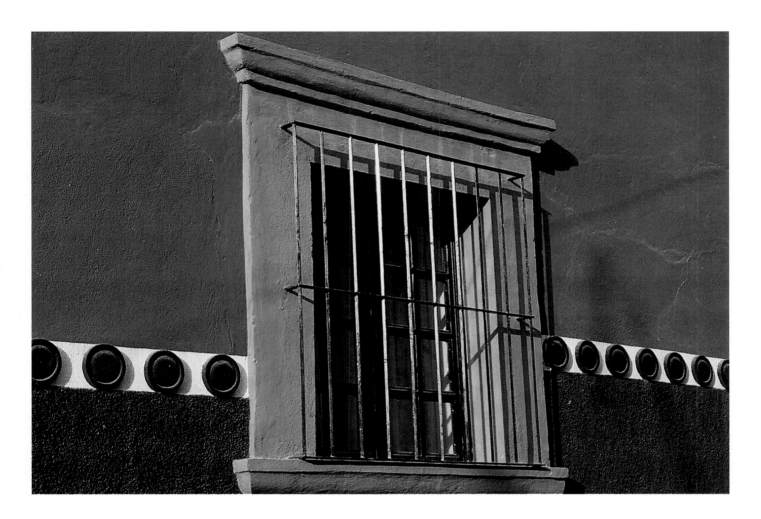

white, and sky-blue paper garlands span the atrium. Paper flowers display the most unbridled colors. Sunflowers and delphinium are delirious; the spikenard casts a spell. A profusion of gold falls as melted wax on heads covered with shawls. The fleshy petals of *cempazúchitl*, the flowers of the Day of the Dead, compete with gold. Flowers of wax and plastic adorn the paschal candles in the ritual of darkness, and on Good Friday children are frightened by the purple sheets that cover the image of Christ, the Holy Trinity, St. Martin of Porres, and Our Lady of Dolors. On the Sunday of Resurrection, color ascends to the ceiling, the choir, the cupola, and the belfry, pounding the air with the tolling of giant bells. On the facade of the church, color overflows, shimmering in the sun like a silver jewel. Suddenly volutes, architraves, and whorls sparkle and bedazzle.

LEFT: **Libres, Puebla. Church detail.** ABOVE: **San Miguel de Allende, Guanajauto.**

The Conquerors did not realize that in homes and temples the "eye of God" of the Huichol Indians slept, painted in black and red and yellow and white rhombuses, the magic symbols of protection against evil spirits. Even today, in 1998, two years before the 21st century, the gods breathe menacingly under the earth, and when one least expects it, they break through the surface to claim their powers.

During the colonial period the Spaniards subjected the indigenous people to their will, not only in religious matters, but also in matters of art. The result was the appearance of radiant altars of pure gold, saints, virgins and crowned nuns. The Conquerors were incapable of understanding the concepts that the ancient Mexicans had about themselves, nature, the universe, their interior drama; this is why they annihilated them.

ABOVE: *San Miguel de Allende, Guanajuato.* RIGHT: *Zacatecas City.*

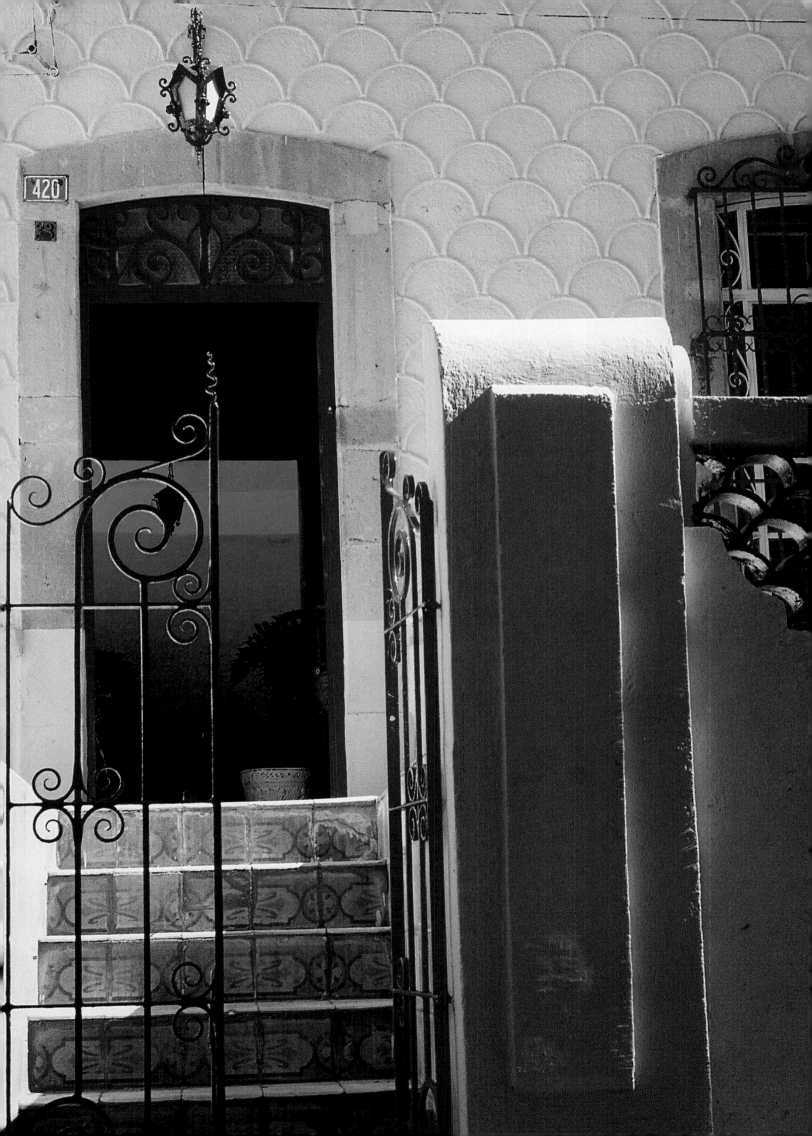

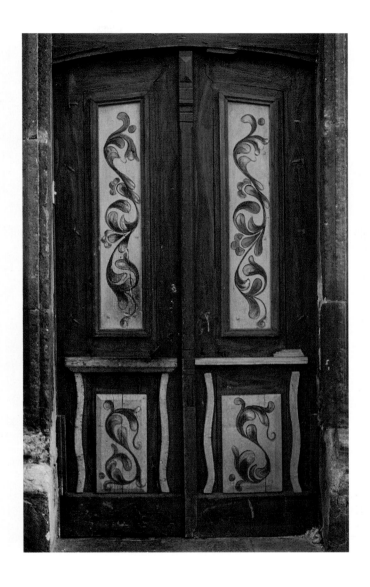

In the midst of this destruction, however, talent surged forth. Creativity exploded, breaking the canons; it came from the center of the earth, the same place the avenging gods come from: Tlaloc, Coyolxhauqui, Quetzalcoatl, Coatlicue, she with the skirt of snakes. They come to shout that they are here, that nobody can finish them off, and along with Christianity, they are here on earth forever and ever, amen.

"Tonantzintla," says Carlos Fuentes, "is an indigenous recreation of an indigenous paradise. White and gold, the chapel is a cornucopia where all tropical fruits and flowers rise to the cupola toward a dream of infinite abundance. Religious syncretism triumphed and with it, in some way, the conquerors were conquered.

"In Tonantzintla, indigenous people paint themselves as innocent angels bound for paradise,

LEFT: *Tepozotlán.* Originally 16th century Franciscan Saint Francis Seminary, later given to the Jesuits, now a museum and church. ABOVE LEFT: *San Miguel de Allende, Guanajuato.* Details of colonial building, with elaborately painted door. ABOVE RIGHT: *San Miguel de Allende, Guanajuato.* Plaza Allende, 18th century arcade, paved in pink stone.

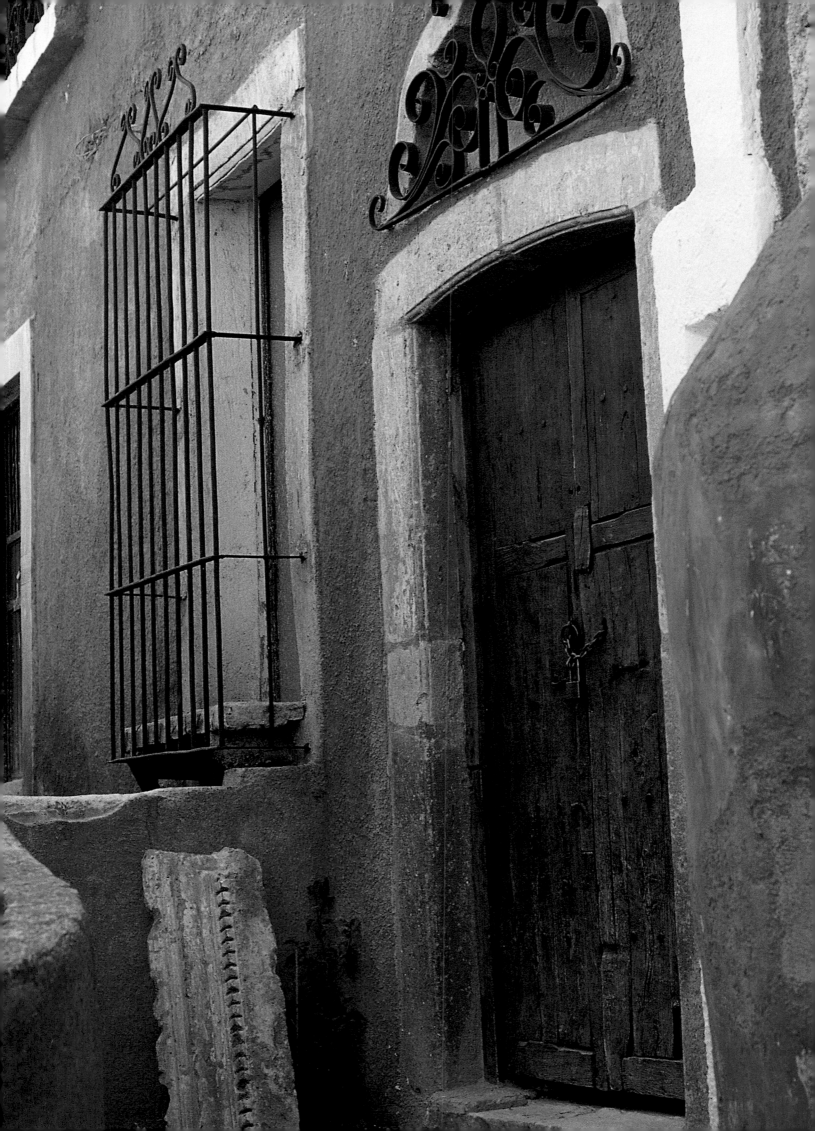

while the Spanish conquerors are described as ferocious red-haired devils with forked tongues. Paradise, after all, can be recovered."

Thomas Gage, in the 17th century, wrote about the majesty of the colony: "It is a well-known fact that in Mexico four things are beautiful: women, dresses, horses, and streets. I would add to this the beauty of the carriages of distinguished people, which are better and more costly than the best of them in the court of Madrid and other parts of the Christian world, since no expense is spared to enrich them with silver, gold, precious stones, gold-embroidered fabrics, and silks from China. And to the elegance of the horses, pride adds the costly livery and the silver horseshoes. The streets of Christianity cannot be compared with those of Mexico in width and cleanliness, nor in the opulence of the shops that flank them. The silversmith shops and their works are particularly admirable. Indians and Chinese immigrants who have converted to the Christian faith have overtaken the Spaniards in this trait.

Men and women are punctilious in their attire; they wear silk, more than wool or cotton. Precious stones and pearls aid in their vain ostentation. It is common for gentlemen to embellish their hat band with diamonds, while merchants use pearls for the same effect.

"Moreover, a black woman or a dark slave girl will ingeniously manage to find what she needs to be fashionable, even pearl necklaces and bracelets, and earrings with valuable gems. The garments of the lower people, black and mulatto (a mixture of Spaniards and blacks) are so light and their carriage so seductive and provocative, that many Spaniards of even the best social class (who are very inclined to sensuality) disdain their own women in favor of these."

After the Mexican Revolution of 1910 (which preceded the Russian Revolution by seven years), our muralists Orozco, Rivera, Siqueiros, and Tamayo would paint *al fresco* like Giotto, Uccello, Fra Angelico, and Cimabue. Just like the Renaissance monks, they had to face the problem

LEFT: *Guanajuato City.* Blue house with extensive ironwork. ABOVE: *Oaxaca City, Oaxaca.* City center. Blue anil and red pigment with colonial window bars.

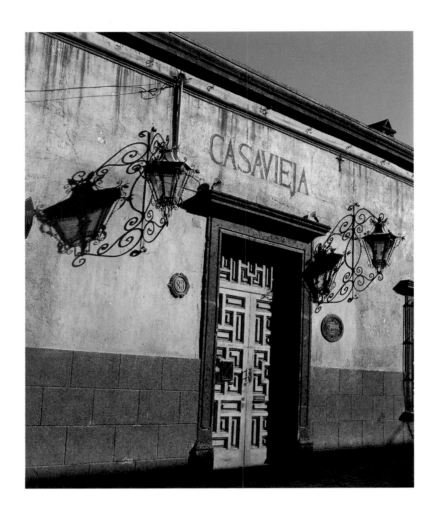

of color application. Javier Guerrero would suggest using the "slobber," or sap of the *nopal* cactus as glue or adhesive, as the construction workers did when they decorated the walls of their *pulque* bars. Frida Kahlo painted with her students known as "the Fridos"—Fanny Ravel, Arturo Estrada, Arturo García Bustos–the *pulque* bar La Rosita in a corner of Coyoacán, now destroyed, although La Siempre Viva is still open.

Mexico has never been as glorious as it was when its great painters lifted their red brushes: Orozco, Rivera, Siqueiros—Tamayo, too, except that his brushes were pink because he did not share the ideas of his elders. Diego Rivera came back from Paris sick of the overcast skies, the gray sidewalks, the pale skin, the white arms that wrinkle at the elbows. He no longer desired a blue-eyed woman. He wanted to get mad, to see

ABOVE: *San Miguel de Allende, Guanajuato.* RIGHT: *Mexico City, Coyoacán.* Church of San Juan Bautista.

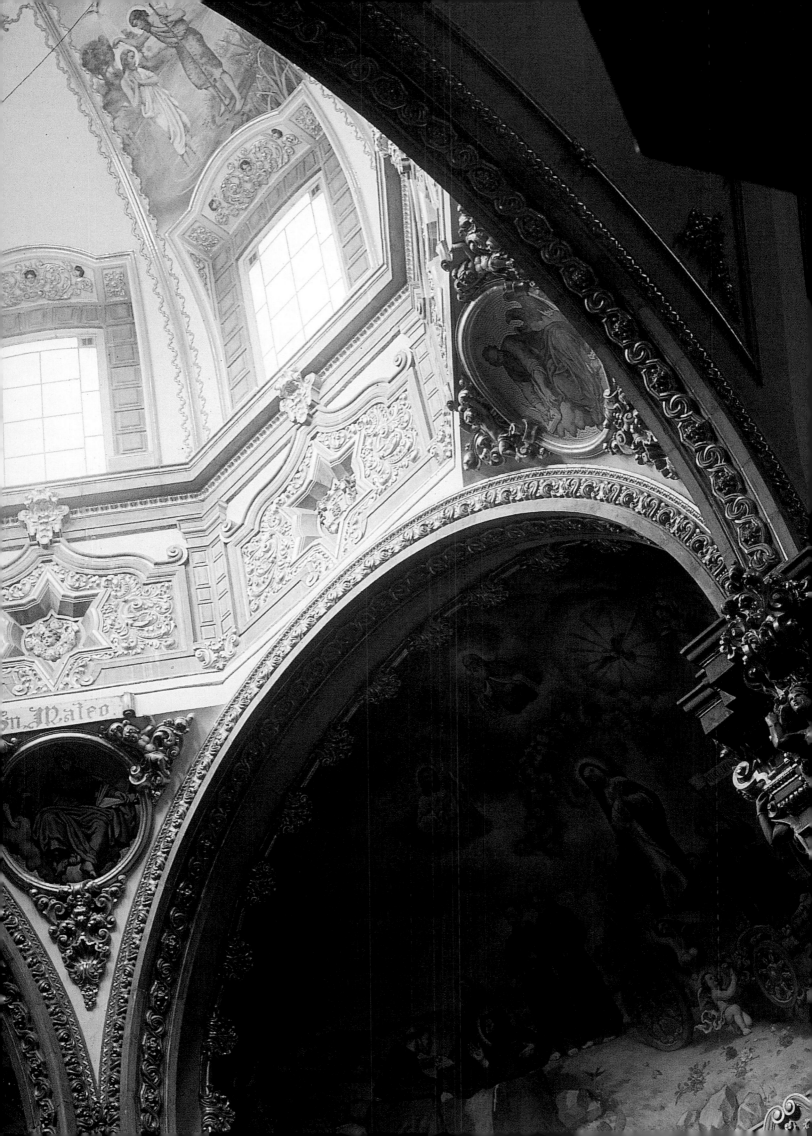

red. (To turn white is to lose all color, to faint.) He flinched from the tints of delicate watercolors. Cézanne and his still lifes of delicious color, good enough to eat, had shown him the way. Cézanne's color had mass, consistency. His painting was not static; it throbbed. His volume looked like that Mexican pink and golden yellow of Guanajuato (Rivera's birthplace), a color with the capacity to round all angles, to give bulk to a surface, to make breasts fuller and strengthen all forms, impregnating them like wombs.

Color exerts its power over the mood of men, women, children, and even animals. Bulls charge at the red cape, and women throw red carnations into the ring to please the bullfighter. We women are tied to climate. Bad weather depresses us. We watch the rain fall down with our heads pressed against the window. Rain does not sadden

ABOVE: *Guanajuato City.* A small street behind the Juarez Theater. RIGHT: *Tlaxcala City.* Green wall.

Color exerts its power over
the mood of men, women, children, and even animals.

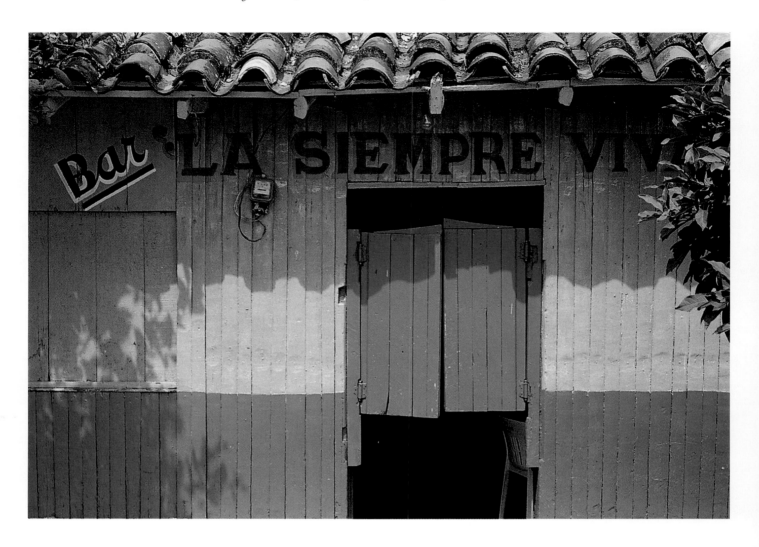

us: what bothers us is the lack of light. We cannot stand too many gray days. We look for the colors of the sun. Red produces formidable energy, and orange operates a liberating action over our mental and bodily functions. Yellow makes us ascend into heaven. Green harmonizes and balances. In another time, hospital walls were pale green, "Nile-green," almost waterlike in Mexico, to soothe patients' moods.

Color is light, and light is a flux of energetic particles traveling at a speed of some 186,000 miles per second through space. Colors sprout under sunlight, and that is why the palette of the English countryside is soft, so too that of the docile French gardens. In contrast, the power of Latin America resides in its luminosity. Light gives consistency to each country. Its power also produces realities and fictions. In southern

ABOVE: *Near Tlacotalpan, Veracruz. Country bar.*

France, Picasso invented the Blue Woman, and because of his influence over human imagination she is now more color than woman, more creation than reality, and she covers a whole era: the blue era. The enormous yellow portrait of Olga Tamayo makes us remember her as a sun-woman, wrapped in her Congo-yellow dress. She turns before our eyes, as do the sunflowers that Van Gogh painted, more real for some people than the ones born of the earth.

We live in a country where pigments swing in the atmosphere, contaminating the air; reality oscillates on the tightrope, it is a *piñata* of tissue paper, a rose in the wind, a four-point star that dances over the heads, shoulders, and arms of adults with childish minds. In the markets abundance creates tunnels as in a gold mine. Fruits pile up, classified by color, and one can traverse long monochromatic corridors: avenues of oranges, mountains of pineapples, walls of carrots, passageways of dark green avocados, barricades of bananas, trenches of watermelons, walls of melon, and a tight tapestry of grapes that fall like rain on your back. All you have to do is extend your arm in this underground city, built inside fruits and vegetables. We are miners, coming to the surface with treasures in our hands.

Sensuality condenses and becomes stone. Sensuality erupts in a Mexico where the fires of volcanoes have never been extinguished. Ocher and red: class struggle is rancorous, it stalks its victims in the street, or in the country, gun in hand. To fire a

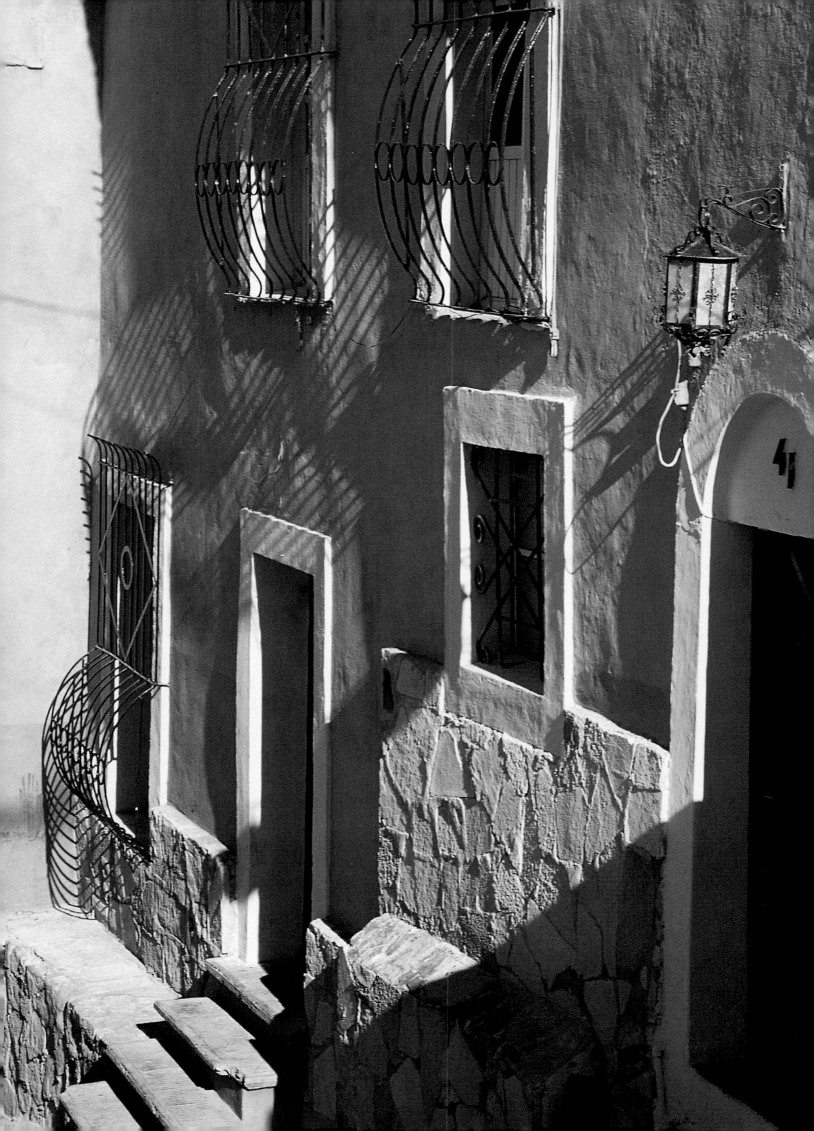

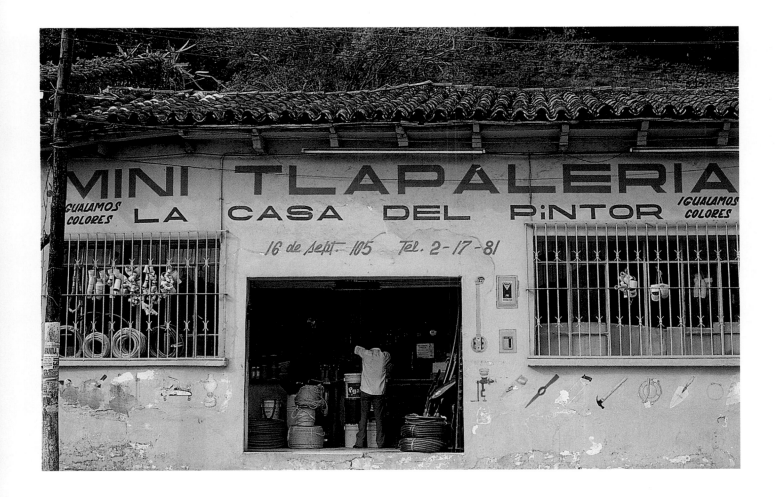

weapon is to fill the sky with red and the earth with blood. All Mexicans are makers of fireworks. We love fireworks. High red pomegranate! In the Latin American continent all colors wait for their liberation, and there we have the painters with wide brushes covering walls on a street with yellow and pink (the yellow of hardware stores as pre-Columbian as our Mexican word for hardware, *tlapalería*), purple and spinach green, red and blue, even if they clash, hate each other, and loudly reject their coexistence. Finally, one must smile. In Chiapas, too, in the mountains of the southeast, the Zapatista subcommander Marcos says that the laughter that dances in the lips of children is yellow, and he also maintains that when the green aches, it is because it wants to be red.

LEFT: *Guanajuato City.* The light pink is not a color commonly seen in Mexico. ABOVE: *Papantla, Veracruz.* Tlapaleria Shop. A traditional hardware store. Stores of this kind are usually painted bright yellow.

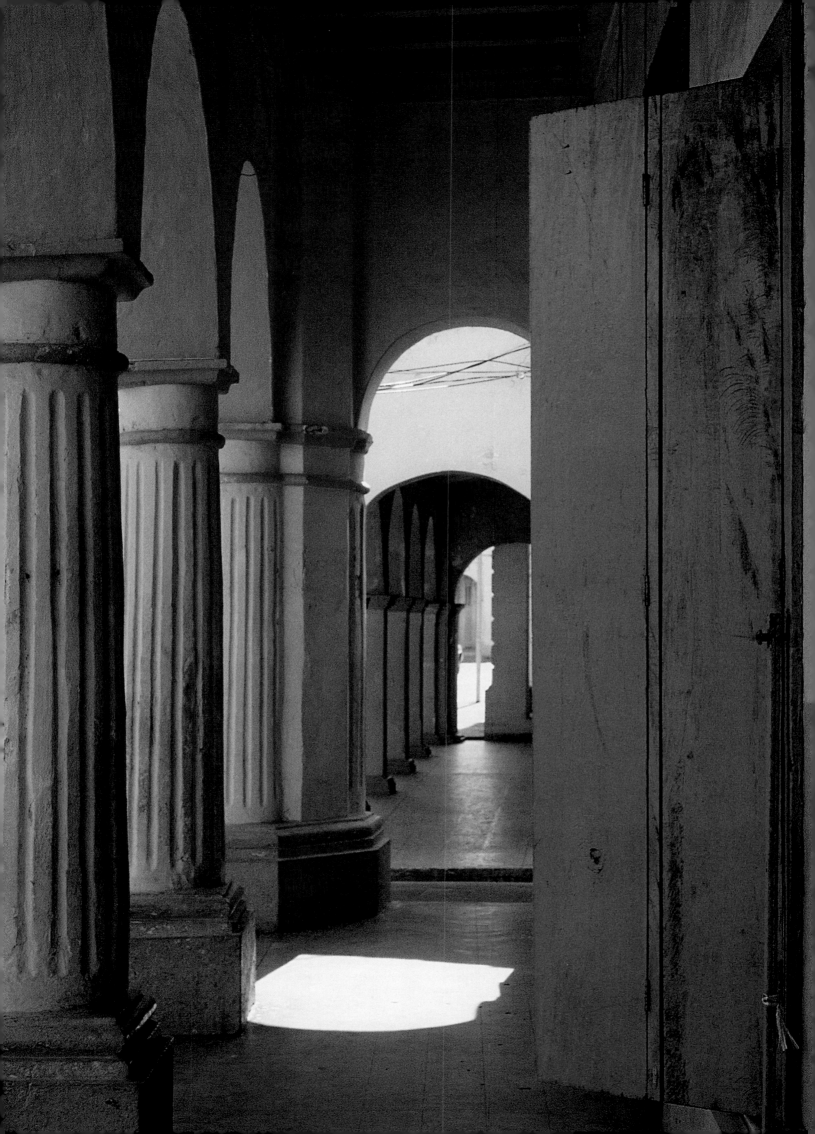

A Sky-Blue Balcony

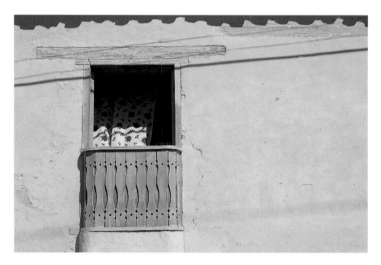

...in Mexico the people who have no money make their walls beautiful to show off their one element of wealth: color.

A TALL AND SPRIGLIKE girl, a beautiful girl with her hair up and a camera hanging from her shoulder; takes long strides on long legs. Her name is Amanda, and she has almond eyes. Emotion halts her; she stops, focuses her lens, and a click startles in the air. Her artist's eyes absorb forms and colors, and color fills her retina. Her enthusiasm grows, and she is a child in a candy shop. She would like to be everywhere

LEFT: *Tlacotalpan, Veracruz.* The light in this town is hazy in contrast to the dazzling light of the highlands.
ABOVE: *San Cristóbal de las Casas, Chiapas.* Wooden balcony of a type seen frequently in San Cristóbal.

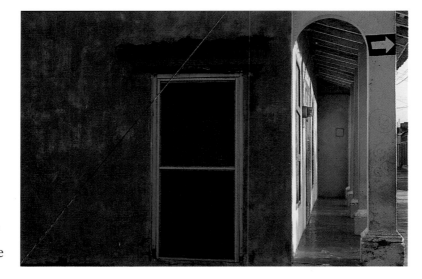

at the same time in the market. Candy and masks hold her in thrall, and so do the fruit and flower stands. The blue sky beckons her from the outdoors, a blue sky so strong that it may well swallow all the rest of the colors in her photographic composition.

Amanda studies the colors. They should compete, but not cancel out each other. She engraves them in her heart. She reads and reflects. The cobalt blue that is often painted on the bases of the houses in small towns as a mud guard protects the paint from dirt, but even more importantly, it scares the evil spirits. It is a belief imported from Morocco. In Mexico,

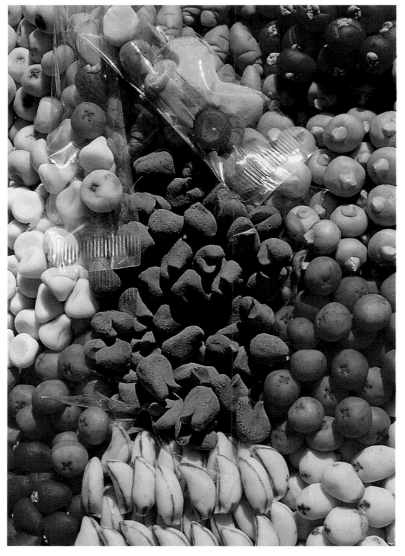

it is also thought that the strip of blue paint around the frames of doors and windows is a protection against the evil eye and all sorts of negative vibrations. At any rate, the empty space of the door or window so framed gives the illusion of depth and strength.

Amanda chats with the people on the street. She sees what others do not. In the market of Oaxaca, the vegetable merchant Doña Silvia tells her that her colors are pistachio green and ocher, but she can also wear red because she is white. Brunettes cannot, because red makes their skin look green, and the

ABOVE: *Tlacotalpan, Veracruz.* BELOW: *Mexico City, Coyoacán.* In the plazas or *zócalos* throughout Mexico, sweets are commonly sold by street vendors. This picture is of the typical marzipan of Mexico, brightly colored to attract attention. RIGHT: *Near Merida, Yucatan.* Geometric division of turquoise, scarlet, and lilac. FOLLOWING LEFT PAGE: *Tlacotalpan, Veracruz.* Shades of blue differentiate adjoining houses. FOLLOWING RIGHT PAGE: *Guanajuato City.* Small alley with pink and orange wall.

MEXICAN COLOR

78

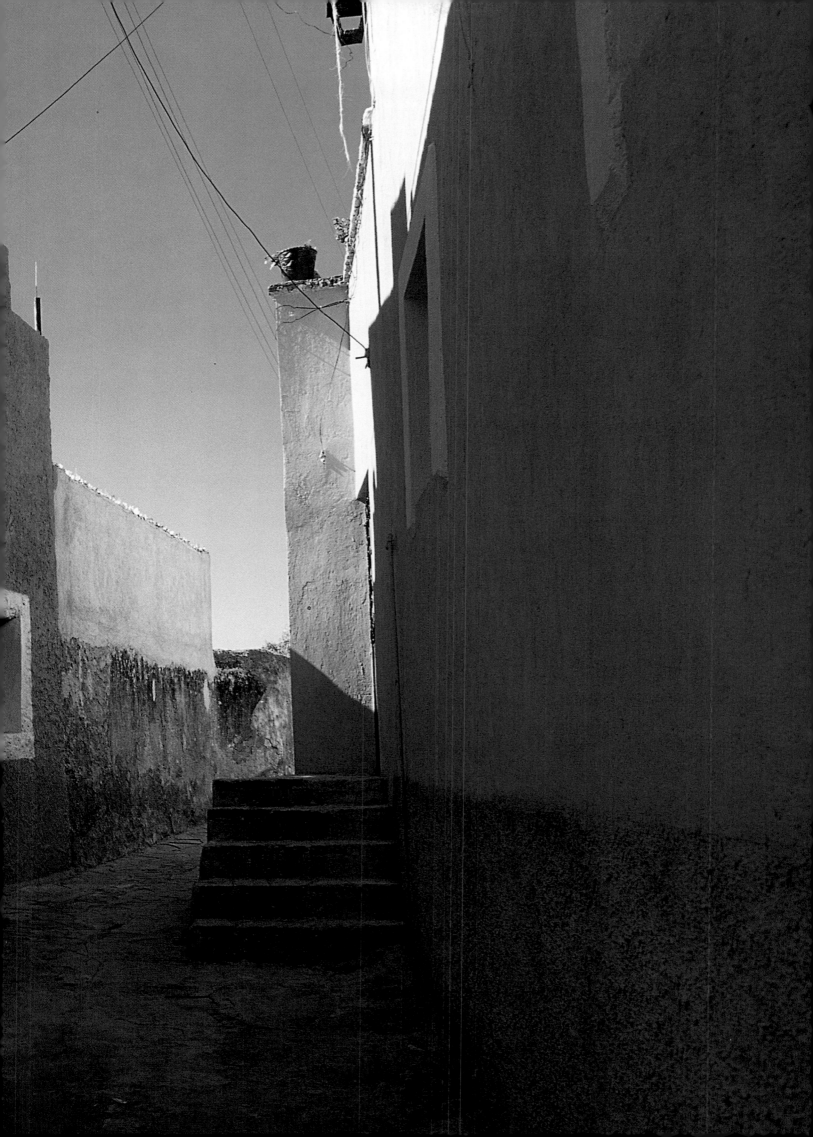

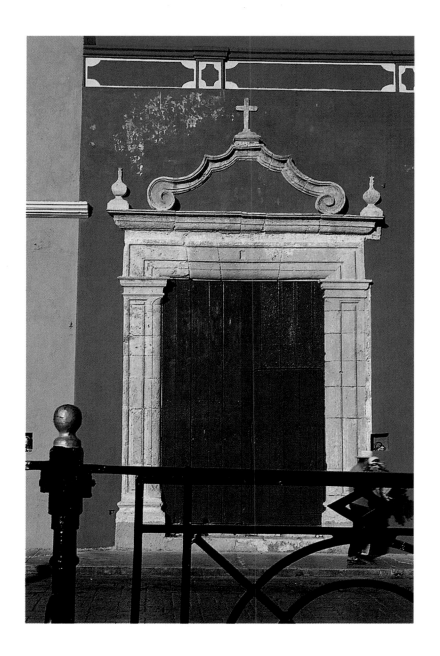

purple of bad intentions also surfaces. According to Doña Silvia, the reason why *huipiles,* the traditional blouses, have so many colors is that the women who embroider them are happy. Orange and red interweave to create a garment where occasionally a small detail in blue, green, or black appears. With a needle and contrasting threads they widen a belt that will be used to tie a deep blue skirt. Indians know that it is not necessary to

bombard their palette, that a slight touch is enough, just a little thread of light to achieve the necessary emphasis. And to make it more personal, each *huipil* will have a strip of multicolored flowers to finish it off.

In Campeche, the most beautiful and most ancient walled city in the country by the Gulf of Mexico, the peagreen of some buildings surprises Amanda, because it reminds her of the tenderness

MEXICAN COLOR

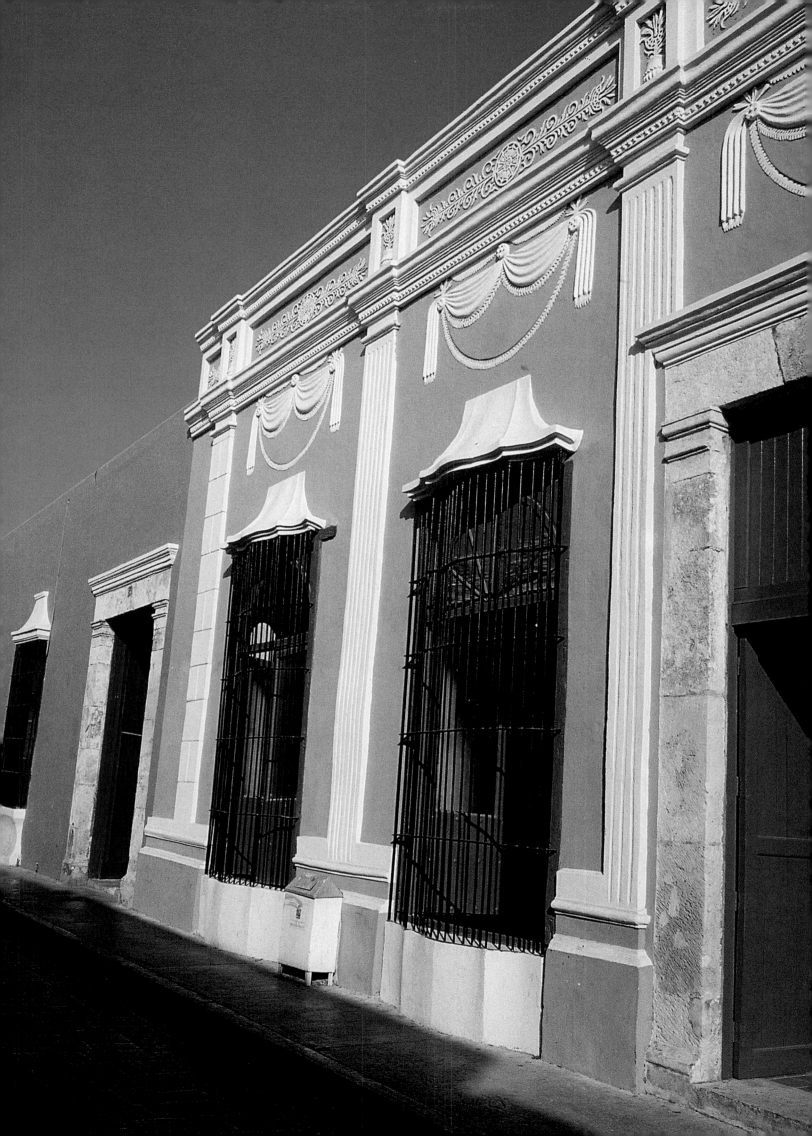

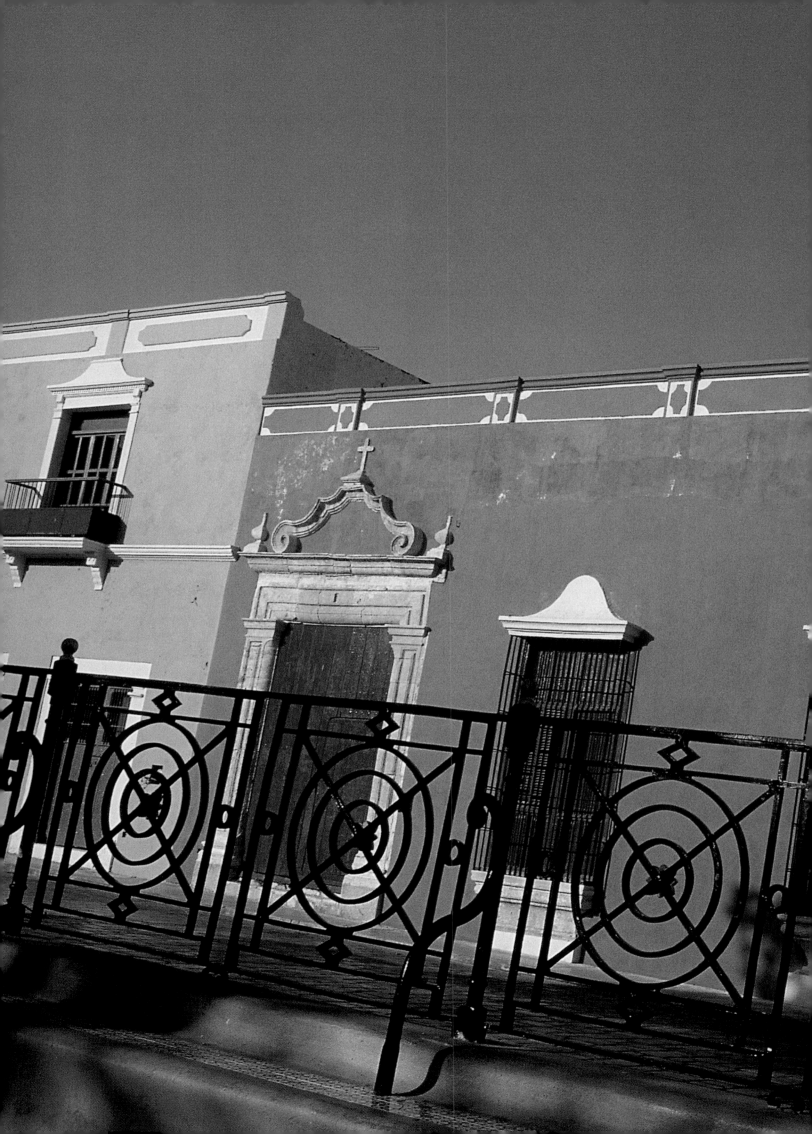

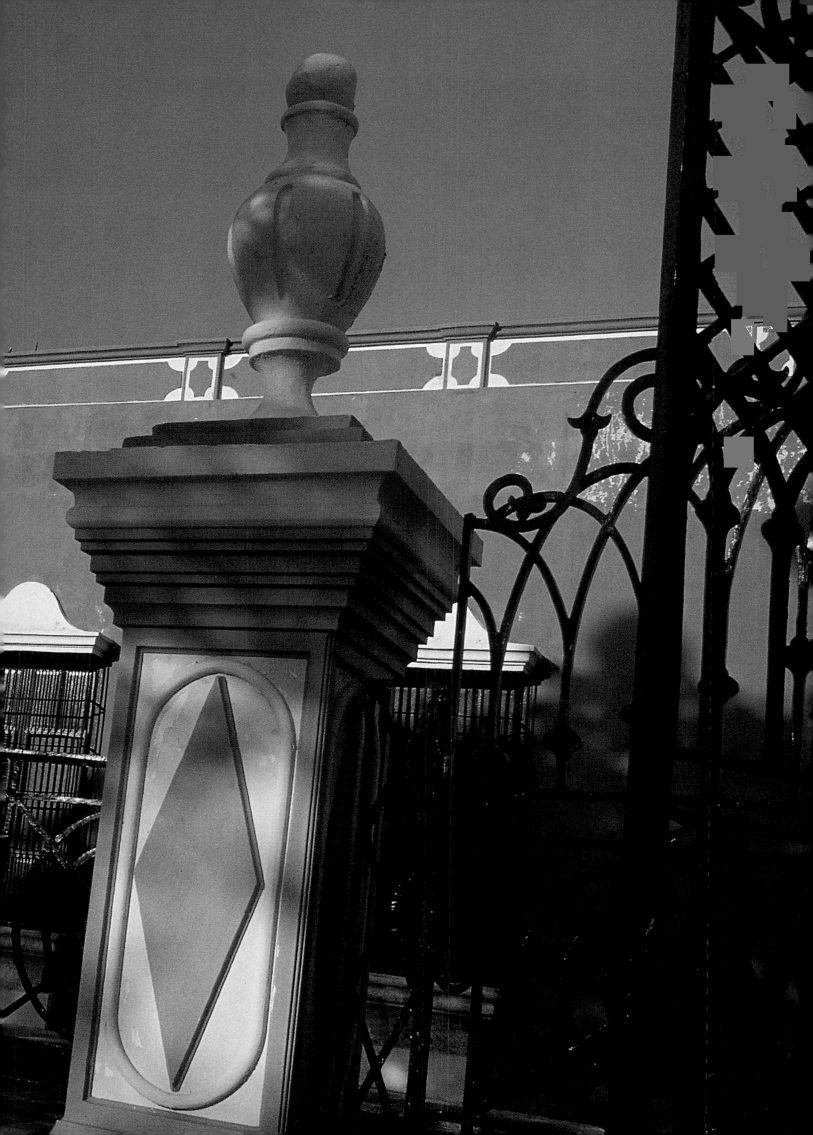

of the fields of her childhood in England. In Campeche, three wooden swans sculpted into a balcony capture the attention of the child she once was. Pirates and buccaneers appear at the turn of a corner. The wall before the sea is partially destroyed, but its vestiges take her to the past.

The neoclassical friezes with their marshmallow colors stun her. A jingle bell sounds in her ears, and she remembers being seduced by the conches, the Maya spirals, and the decorative details in Cacaxtla.

The 18th century-style houses of

Campeche retain their nobility, and their enclosed entrances invite the sea breeze in. The patina on the walls has preserved their poetry. Campeche was renovated in a neoclassical style, and even when there are still noticeable colonial relics, the colors have nothing to do with the colonial period and much to do with the Caribbean—pale green, pale and naive yellows. Only a few houses maintain the brick-red colonial color, unlike Tlaxcala, the colonial city by definition, which is paved in octagonal tiles of red and white.

Amanda stops

OVERLEAF: *Campeche City.* Merchant's house on the south side of the zócalo, dating from the 18th and 19th centuries. Settled in 1535, Campeche was one of the first cities in Mexico. Due to the great demand in Europe for the red dye extracted from the wood of the *palo de tinte* tree, Campeche became prosperous. The house dates from the 18th and 19th centuries.
ABOVE AND RIGHT: *Campeche City.* Neoclassical details on houses within the fortified town.

before a wall. In Tlaxcala, an arrow shows her the way. It is so clear that Amanda must obey. The wall is deep blue, and the arrow is red. Such a wall is surprising because this city is like a fragile porcelain doll, dressed in white lace and starched petticoats. Tlaxcala is exquisite, feminine, almost a wedding cake. Amanda must register the strident blue wall and all the coquettish ornaments of the town: the rosettes, the filigree, the well-braided hair of women, the fire-tongues of bricks.

In Guanajuato, three lines of shadow produced by three beams are re-

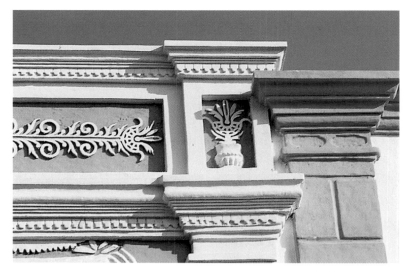

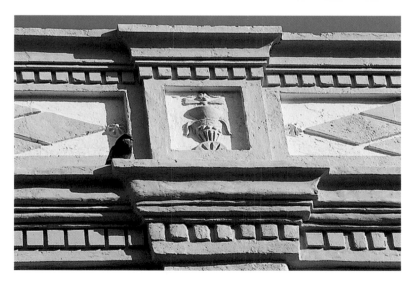

flected on the floor, and just as in the case of the red arrow on the blue wall, it is up to us to decipher the message.

Guanajuato, a mining town like Zacatecas, is our labyrinth of solitude. There the houses built next to each other interfere with the privacy of their dwellers. The "cul-de-sac of the kiss" between walls that almost come together commemorates an ill-fated couple who kissed but never married, their simple act having been inflated to a scandal of the whole city of Guanajuato.

Ay! Amanda now walks between complementary

walls, purple and scarlet, and the light projected between the two changes the perspective of the whole street. Scarlet is a pre-Columbian color. As she captures the ladder leaning against the wall, she is singing an old song:

> "All you need to climb
> up to heaven is this:
> two ladders, baby:
> one small and one big."

Amanda says that in Mexico the people who have no money make their walls beautiful to show off their one element of wealth: color. "Yes, yes, we have what it takes to fix up the place," say the boisterous walls in yellow, purple, turquoise, pink, orange, and blue. In that vibrant light is their fortune. If the blue came to us from the Moors, ocher and red probably came from Italy. From the Middle East we inherited the tradition

ABOVE: *Guanajuato City.* An example of pre-Columbian red and ocher. BELOW: *Guanajuato City.* An adobe wall made from inverted arches. RIGHT: *Guanajuato City.* Varying use of ocher pigment, characteristic of Guanajuato.

of arches and blue tiles, and we find them even in gas stations! But it takes the Mexican popular painters to be concerned about details that wouldn't worry anyone else on earth: a small color frame up high on the ceiling to break the monotony, or a very fine line separating one color from the other, making them both shine. In a state of wonderment, Amanda Holmes preserved that green line over the mud guard, along with the garlands and acanthus leaves,

and the tiny tiles that pay homage to both colors.

In San Miguel de Allende, the inhabitants also paint a thin stripe dividing two surfaces.

In San Cristóbal de las Casas, Chiapas, in the luxuriant extension of the woods, the Mexican pink and orange of the *huipiles* worn by men and women stand out. People are hardly a dot in the greenery, a pink light walking toward its liberation: the jungle. The many-colored ribbons around the *tzotzil* hats swing in the sun. In their

LEFT: *San Cristóbal de las Casas, Chiapas.* Colorful details. ABOVE: *Campeche City.* Violet strip opposing the lemon yellow door.

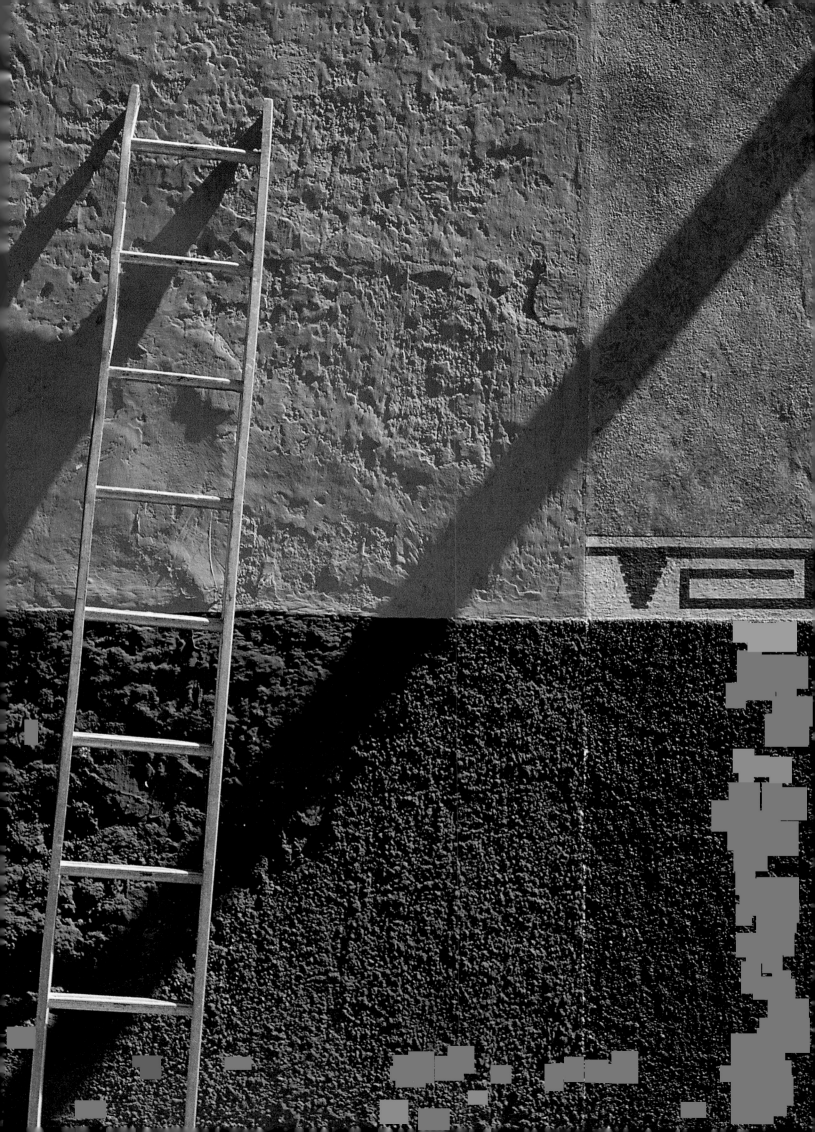

cities, the people of Chiapas combine yellow and lilac, flag green with dark blue, cobalt blue with yellow, pink with orange, indigo blue with jade. The people set the colors to fight like roosters: all colors are enemies, and in the end the winner of the battle is art itself, because opposites attract each other and they end up embracing. No complementary colors here: the spirit of yellow clashes with pink. The result of the combat is fortunate. Clothing hanging out to dry in the sun, on the roofs of houses, is as multicolored as the facades: Mexican pink, spinach green, indigo blue, Congo yellow, purple as in Good Friday. White possesses all colors, and little girls are dressed in white because they are a promise of the rainbow they have inside. Churches are also painted yellow because yellow is the color of wisdom, just as the Chinese said. The Cathedral

LEFT: *San Miguel de Allende, Guanajuato.* Different colors delineate the boundaries between the houses. Note the pre-Columbian design above the splatter guard. ABOVE: *Huasca, Hidalgo.* Rancho Santa Helena. Ladder against pre-Columbian red wall.

and the Church of Guadalupe emit golden rays. All the light of the sun is reflected from their walls, which open like arms. In San Cristóbal, Amanda is amazed by a small balcony painted pale blue, like the dress of the doll in the song: "I have a doll, all dressed in blue…" A naive blue, yet it is there, challenging the deep omnipresent blue of the sky.

The most playful and innocent colors are those of Tlacotalpan, and Amanda is ecstatic before the arches and the portals, and the interplay of shadow and light on the walls of the houses painted sky blue and lavender-

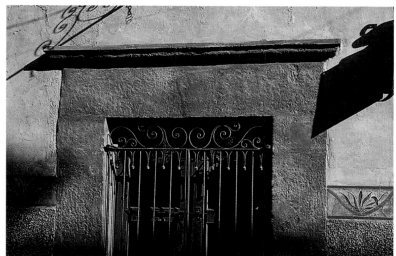

blue, with bougainvillea cascading over the ocher wall. Doña María Ascaño Andrade opens the door of her house like a flower, and invites Amanda to sit in a rocking chair where she becomes once again the girl in Lewis Carroll's *Alice in Wonderland*. She laughs, holding the camera in front of her eyes. In the market, plastic ceases to be a despicable material—a row of colorful blown-up balloon dogs makes it honorable. Plastic is redeemed, now that it too has the power to make us marvel. Out on the streets we are reconciled to the colors of automobiles:

LEFT: *San Miguel de Allende, Guanajuato.* In San Miguel it is common to see intricate details of this kind. ABOVE: *San Miguel de Allende, Guanajuato.* Different colored walls surrounding pink stone door. CENTER: *San Miguel de Allende, Guanajuato.* Window surround with typical San Miguel decoration above the splatter guard (*mata barros*). BELOW: *San Miguel de Allende, Guanajuato.* Typical of San Miguel de Allende is this decorative detail.

a surprising pink next to a vermillion red.

In Oaxaca, painter Francisco Toledo thought the plaza near his house looked sad, so he had two houses painted in bright colors that apparently do not go with each other: turquoise, yellow and vermillion, pre-Columbian colors. Immediately the plaza and the surrounding streets began a joyful tap dance.

The boats with oily colors, almost edible, float on the chocolate-colored waters of Xochimilco, America's Venice. The barges named *Rosalba*, *Tomasita*, *Andrea*, *Nicolasita*, *Viviana*, *Manuela*—words written over arches covered with flowers—they are another obsession of our photographer. Xochimilco is a proletarian town. On Sundays, entire families board those boats, and glide through the canals, driven by a gondolier more skilled than any Venetian, eating *mole*

MEXICAN COLOR

(called by the French *poulet au chocolat*), Mexican rice, cactus salad, and drinking beer and sodas. Patricia Guild, the English home-fashion designer, was inspired by visits to Mexico to launch a new style of decoration that is wilder, freer, more creative. Colors never before combined leap outside their cage. Patricia opened the gate.

There is something bothersome about the deep red that the walls of some Mexican houses are painted. It looks like a wound, as if the pigment had been thickened with blood. The Náhuatl stories tell us that in the old colonial palaces of the city's center, the *tezontle* stone is the clotted blood of our ancestors, their innards scattered on the wall. The many bloods have become one single blood to color the Plaza of Sacrifices.

Colors come from the red clay. In the

ABOVE: *Tlacotalpan, Veracruz.* Neighboring pillars of vibrant colors. BELOW: *Tlacotalpan, Veracruz.* Pillar detail.

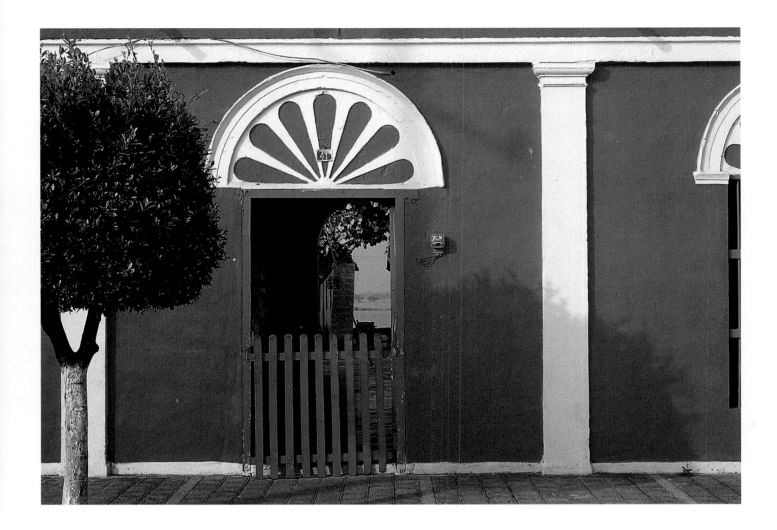

provinces, browns and reds are mineral colors extracted from the soil, which craftsmen sift and sometimes heat to darken a hue. In Querétaro, the stone is pink; in León it is green, and in Zacatecas, it is ocher and peach-colored. The Mayan blue is perhaps the only organic pigment fixed on white clay. Our ancestors were highly sophisticated and achieved complex color techniques that today's experts might envy, especially in the mixing of

soils, vegetable gums, and limestone to make colors that adhere to the surface.

How Goethe would have liked to have added Mexican pink, also called Tamayo pink, to his *Theory of Colors*, which Kandinsky would elaborate on later. Goethe would have told us that, psychologically speaking, color is a sensation, but from the point of view of physics, color is the longitude of a wave inside light or any

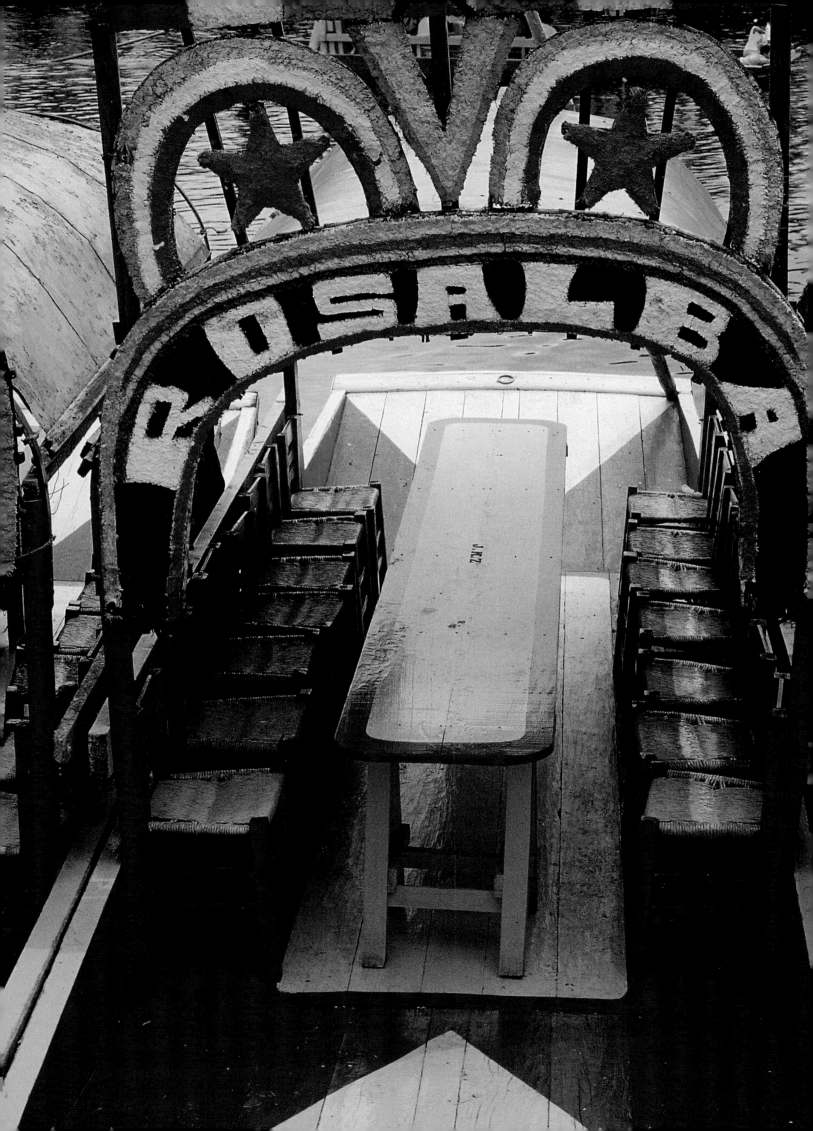

other radiating energy. And we Mexicans, so fond of selling our souls to the devil, would have loved to show Goethe our Atl-red, the color invented by Doctor Atl, the pseudonym of Gerardo Murillo, painter and volcanologist; he is the only man we know of who actually descended in red fire to the bottom of Hades, the burning crater of Popocatepetl. He later defied the magnificent eruption of Paricutín, the volcano from Michoacán, whose lava buried several towns.

PREVIOUS PAGE AND LEFT: *Mexico City.* Xochimilco is in the south of the city. It is made up of a series of canals that embrace floating islands. These vividly colored boats ply the canals. ABOVE: *Mexico City, Xochimilco.* Boat detail.

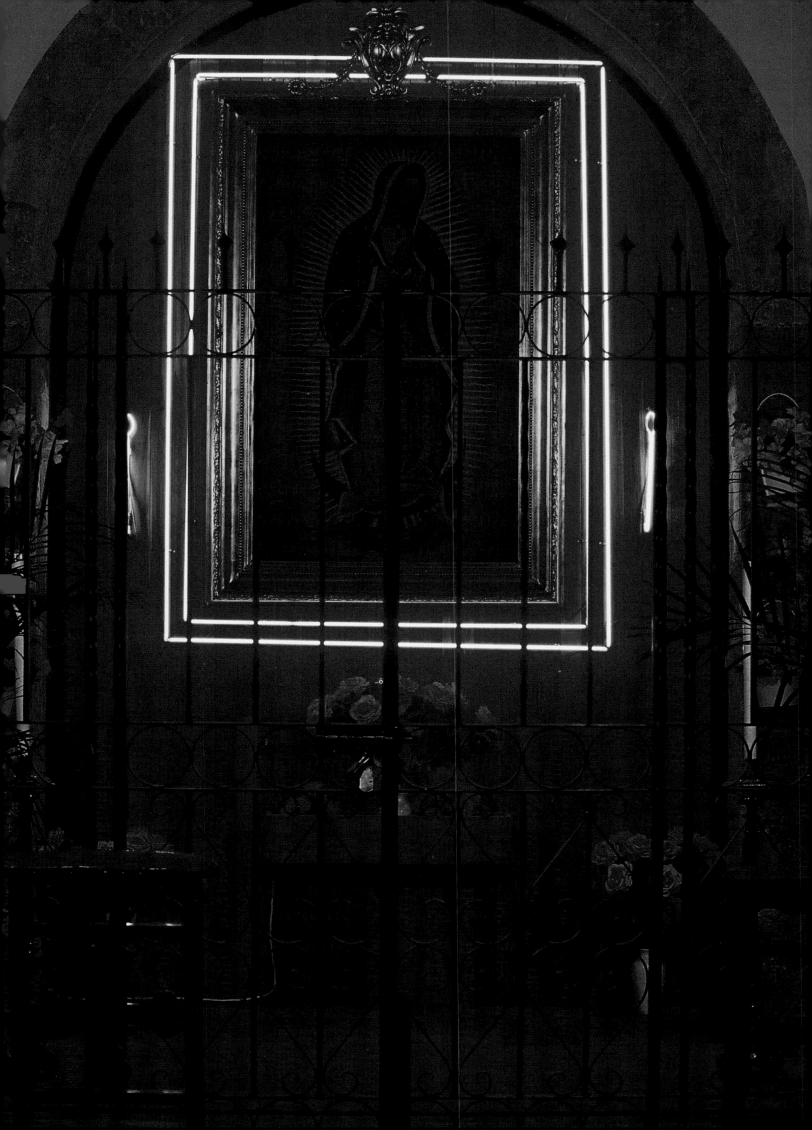

CHAPTER FOUR
The Brown Madonna

Each December twelfth, the feast of the Virgin of Guadalupe is celebrated. She has not stopped performing miracles since she first appeared.

WHEN JUAN DIEGO, the young man to whom the brown-skinned Virgin of Guadalupe appeared, asked the Virgin for the proof of her existence the bishop demanded, the Virgin gave him flowers so that he would be believed; she gave him colors, or, as the poet said, a bit of breeze with water.

The Virgin performs the miracle of turning stones into flowers in the rocky landscape of a cruel winter. There are roses, jasmines, violets,

LEFT: *Mexico City.* Santísima Temple. Virgin of Guadalupe with neon frame. ABOVE: *Mexico City.* San Angel Flower Market.

Easter lilies, irises, and even fragrant herbs like rosemary and thyme. In a state of wonder, Juan Diego collects all that celestial spring under the eyes of Mary, who tells him where to find even more. "These roses and flowers are a signal you must take to the bishop," she said. Then Juan Diego puts his harvest of colors in his *ayate*, the cloth he will only unfold in the presence of His Excellency Don Juan de Zumárraga.

He goes to the bishop at the palace, accompanied by lackeys in livery. Juan Diego then communicates the order he has received from the Very Lady Mary, Mother of God. He opens his clean piece of canvas, revealing a holy garden, a miraculous spring of roses, lilies, carnations, irises, jasmines, and violets growing from the *ayate*. Moreover, the colors of the flowers: the red and blue blossoms, the green leaves, the violet of violets,

ABOVE LEFT: *Guanajuato City.* Basilica de la Señora Guadalupe. 17th century construction in the baroque style. The parish church was elevated to the category of a minor basilica in 1957. ABOVE RIGHT: *Mexico City.* Santísima Temple. 18th century baroque church attributed to architect Lorenzo Rodriguez. RIGHT: *Erongaricuaro, Michoacán.* On Day of the Dead gravestones are decorated with many flowers. This African marigold (*cempazúchil*) is a typical flower on Day of the Dead.

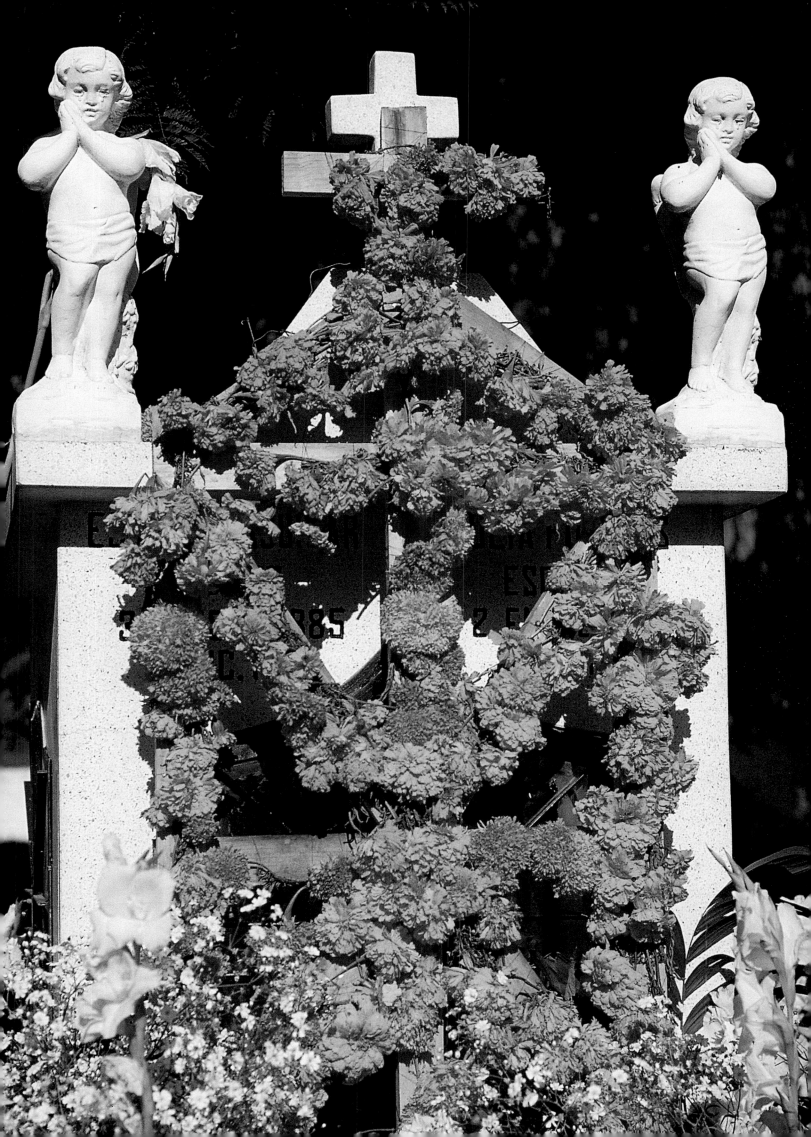

the white of jasmines, and the purple of irises have left an imprint on the fabric: a depiction of Mary, Mother of God, her holy image that is preserved and revered today in her sanctuary of Guadalupe, on the hill of Tepeyac in Mexico.

Besides the flowers, the most important aspect of the painting in the *ayate* of the Indian Juan Diego is the color of the face, neck, and hands of the Virgin: she is brown, just like the Indians. Brown is the color of her skin—like coffee, cocoa, or chocolate. Brown is dark, opaque. Humble is the color of her skin: the color of the earth, of the ditch that is open in the field to plant corn;

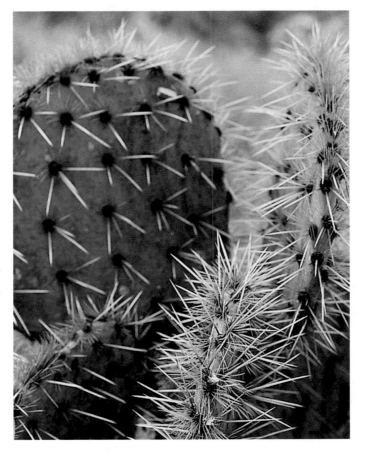

color of poverty. Brown, the color of resilience, strength, vigor, and sorrow.

Color is identity. We are brown because we are Mary's children.

As far as we know, this Virgin chose the peasants, the smallest of them all, the forsaken ones, the forgotten children of the earth. Otherwise she would have come as a white Virgin, dressed in silver and gold, bejeweled. But as it turns out, the Morenita is bejeweled in the colors of flowers.

Five times the Virgin of Guadalupe appeared before Juan Diego, and the fourth time the stones of the hill of Tepeyac, where indigenous people had

the color of the bark of tree trunks, of dry leaves, of domestic animals, of cattle, horses, hide, stray dogs and cats, of sewage rats, and of the habits of Franciscan monks. This is the most humble color, the most enduring, the one that can take it all, for days and months. Brown, the color of those who don't change their clothes every day. Brown, the

always adored Tonantzin, turned into miraculous flowers. Stones turned into flowers. Cacti, such as maguey, and biznaga, sprouted flowers. All desert plants bloomed. The nopal cactus, where the eagle stood to devour the serpent, became a spring of juicy green and scarlet fruit—*tunas* and *pitayas*, thirst quenchers—and flowers that take

ABOVE: **Nopal cactus.** BELOW: **Mexico has the largest variety of cactus.** RIGHT: *San Miguel de Allende, Guanajuato.* **Woman cleaning a nopal cactus in the market.**

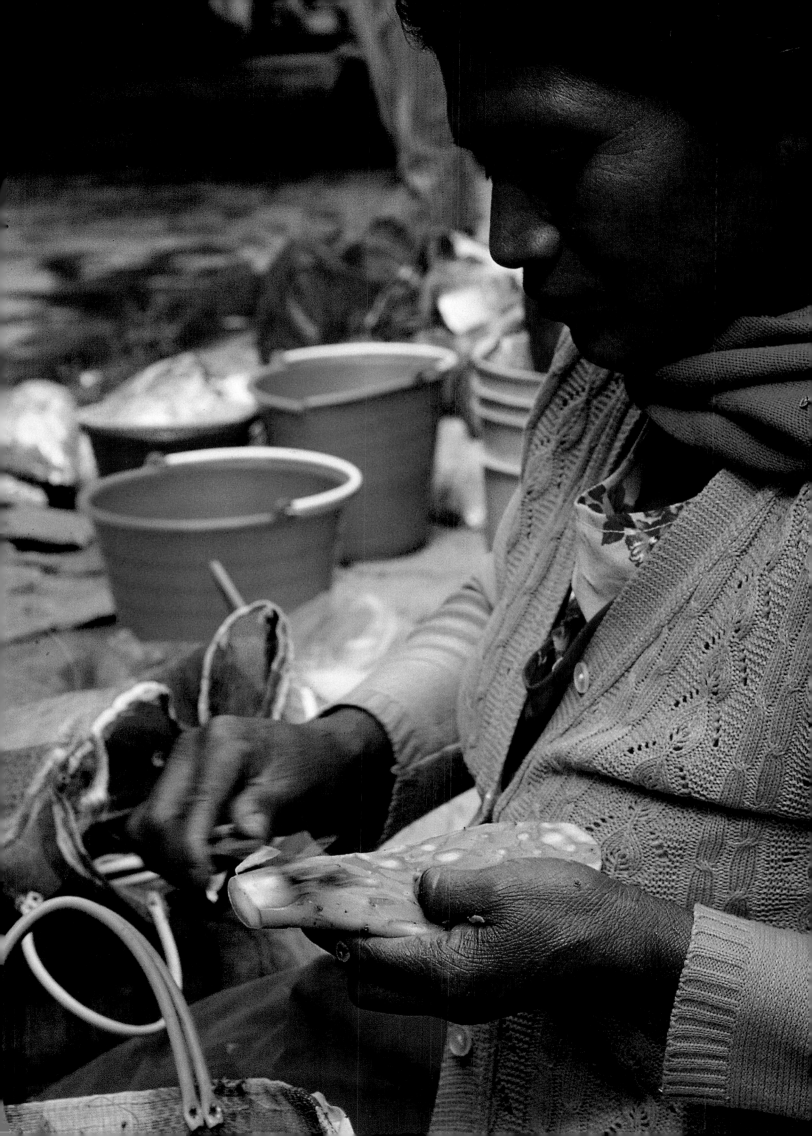

the harshness of climate because, like all women, they are made to withstand.

From that moment on, flowers and colors became a part of the cult of La Morenita. She is Mystical Rose, Ivory Tower, Morning Star, the distributor of favors, the Mother of the bronze race, its advocate, the Empress of the Americas, because "He did not do anything comparable with any other nation." (*Non fecit taliter omni nationi*.)

She is also the diffident rose of the Fair of Flowers the song speaks about, shy because her color is rejected. Now she performs the miracle of allowing Mexicans to be themselves. If she is the dark one, no one can be ashamed of being swarthy.

Bernardino de Sahagún, the Franciscan friar who studied indigenous traditions, wrote in 1570 that the goddess Tonantzin was worshiped on some hills more than twenty leagues away from

ABOVE: *Oaxaca City.* Mexico has a wide variety of sweets of all types and descriptions. BELOW: *Mexico City.* Sonora Market. One of the most astonishing markets is the Sonora Market. This market is renowned for its witchcraft section. It is full of magical potions for every possible use, from curing deadly illnesses to stopping a husband's infidelity. Mexicans regularly visit their witch doctor in the same way that Americans visit their psychiatrist. RIGHT: *Mexico City.* Plaza Loreto.

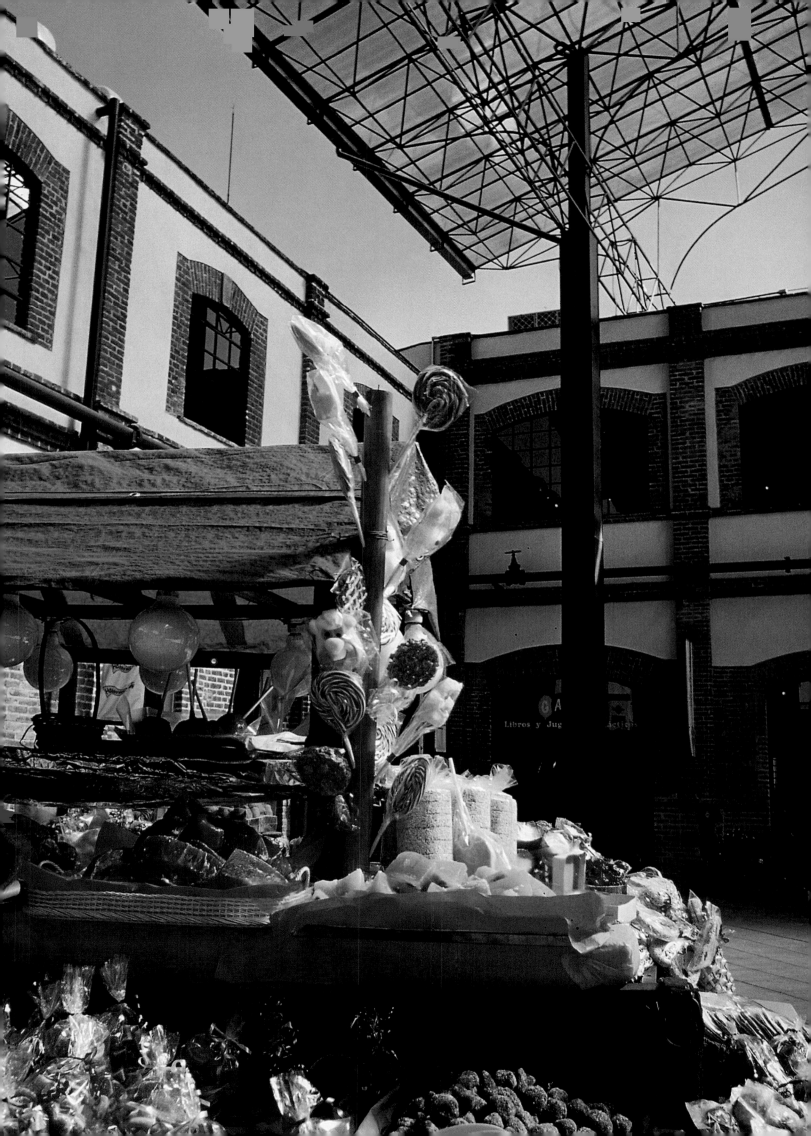

Mexico City, where sacrifices were made to the gods. Pilgrims came to visit Tonantzin from afar, and she was idolized.

The color of idolatry is red, and the color of hope is green. Recalling the pre-Cortesian Tonantzin, Christian believers built a hermitage for the Virgin of Guadalupe on the hill of Tepeyac. The Indians, coming from distant places in the Valley of Mexico and loaded with offerings, ascended the Tepeyac in a hurry to deposit before their Lady their gifts of colorful foods: green and red tamales, amber and black *moles*, white and red rice, cactus salads in exquisite dishes, tortillas in red tomato sauce, large chilies in walnut sauce with pomegranate seeds, chicken tacos sprinkled with shredded lettuce and grated white cheese, tortillas in brown bean sauces—all the victuals that Mexicans place on the tombs of their loved

ABOVE LEFT: *Careyes, Jalisco.* Spring tree. The flowers of this tree have influenced the color of many walls in Careyes.
ABOVE RIGHT: *Mexico City.* Jacaranda tree in flower. RIGHT: *Near Tlacotalpan, Veracruz.* Red poinsettia (*tabachin*) hang over a little yellow house.

ones on the Day of the Dead, the second of November, coming again later to share with their departed ones a glass of Bohemia blond beer, white tequila, or even the Coca Cola they had loved when they were alive on this earth.

Each December twelfth, the feast of the Virgin of Guadalupe is celebrated. She has not stopped performing miracles since she first appeared.

"Long live the Virgin of Guadalupe!" The

curate Miguel Hidalgo y Costilla, the father of Mexican independence, held her up as a standard, presented her likeness before his troops, and to the call of "¡Viva Mexico!"—or "Long live Mexico!" —he invited all Mexicans to rally behind their brown mother. She, commanding the army and leading the guerrillas, symbolized victory. On horseback, the Virgin of Guadalupe went to battle and won one confrontation after another. Each

ABOVE: *Oaxaca City.* This detail of a truck is an example of the great pride people take in painting their trucks bright colors. Such pride is also shown by the flashing colored lights that are a common decoration, making the trucks look like moving Christmas trees.

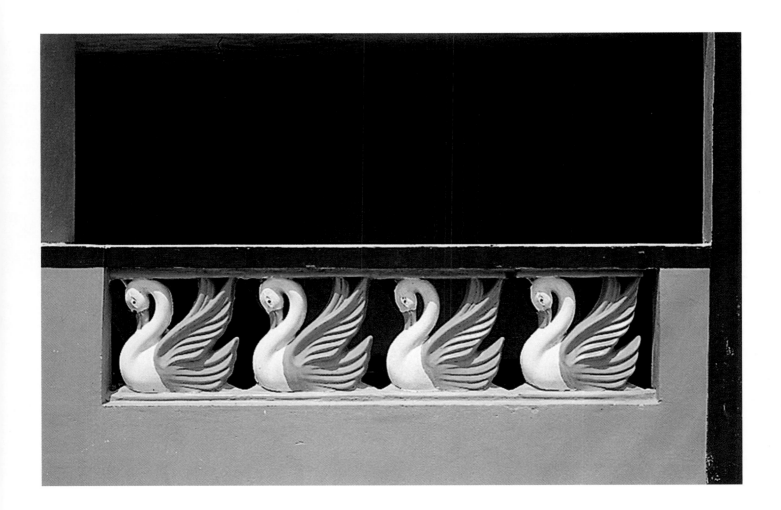

time a soldier fell, she consoled him and took his gun. No army general had been a better chief.

The driver of every bus in modern-day Mexico—the largest city in the world, with 20 million inhabitants—has enthroned the Virgin amid colorful lightbulbs. She is the patroness of all tire repair shops, never mind that she may have to share her altar with Marilyn Monroe or a starlet of the day. For years, famous entertainer Angélica

María was Mexico's girlfriend, and the obligatory sister to our Dark Lady. In hardware stores, the Virgin of Guadalupe is the queen, and she retails not only nails, but also colors.

The Comex paint brand name, with its multiple shades, dictates the fashionable colors for buildings. If Mexicans paint their homes purple, it is only because Comex put that color on the market, and it turns out to wear well and sell cheaply.

ABOVE: *San Cristóbal de las Casas*. Intricately carved swans decorate this balcony.

Strong colors sell best, especially bright and lively yellows—all fifty-two shades! Lemon yellow, canary yellow, chrome yellow, goldenrod, electric yellow, classic yellow, the two darkest, ocher yellow and sienna yellow are among the most popular. Colors also define neighborhoods. In Mixcoac, where Octavio Paz was born, the owner of a paint store answers the question "What colors sell the most?" in this way: "Here? Well, vanilla, white, all sorts of whites: oyster white, celery white, champagne and salmon."

In the proletarian neighborhood called Colonia Obrera, the salesman expounds, "Here we sell strong colors: Neapolitan yellow—they always ask for that one—and concentrated yellow. After that, comes tangerine orange. Here they never ask for green or blue.

"The favorite finish is satin, of course, but

LEFT: *Tlaxcala.* Plaza Xicohtencatl. ABOVE: *Oaxaca City.* Francisco Toledo, a Oaxacan artist, discovered these abandoned houses and painted them bright colors.

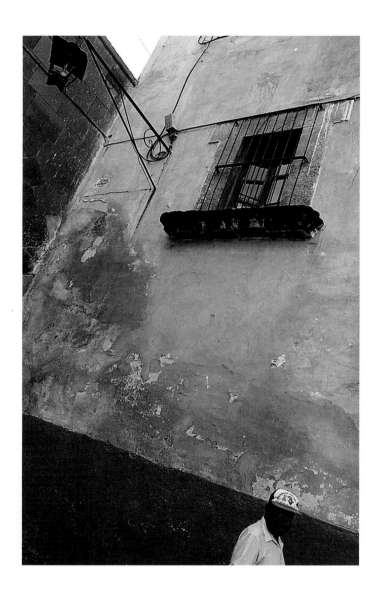

with fifty-two shades of yellow to choose from, Neapolitan yellow is the one that goes. Nobody wants to look like anyone else in this barrio, even if everyone is a relative of everyone else. The colors we sell the least? Grays, hazelnut, Cordoba green, magenta, blue, and lilac."

Naucalpan is the other proletarian colony where darker colors abound: an orangey peach, turquoise, forest green, Neapolitan yellow, canary, dark orange—all very intense because pale colors fade in the sun. People make their money stretch, and since having one's house painted costs a bundle, they want a color that can take inclement weather. Many people waterproof their house at the same time—the rains are coming soon—and they even paint their rooftops, as if anyone goes up to inspect. Inside the house everyone uses pastel colors to brighten the light.

ABOVE: *San Miguel de Allende, Guanajuato.* Time has created patterns on the blue and red wall. This is a prime example of the pre-Columbian red and blue. The red color is made from hematite, iron oxide, and lepidocrocite. The blue color is made from pirolusita and an unidentified organic substance. RIGHT: *Oaxaca City.* Window with orange and purple layers of paint. FOLLOWING PAGE: *Oaxaca City.* Shops vividly defined through color.

BOLSAS DE DAMA
MONEDEROS
PORTAFOLIOS
MOCHILAS ESCOLARES
" DISTRIBUIDOR "
SAMSONITE

219-A

RTICULOS

VIAJE

ZOILA REYNA

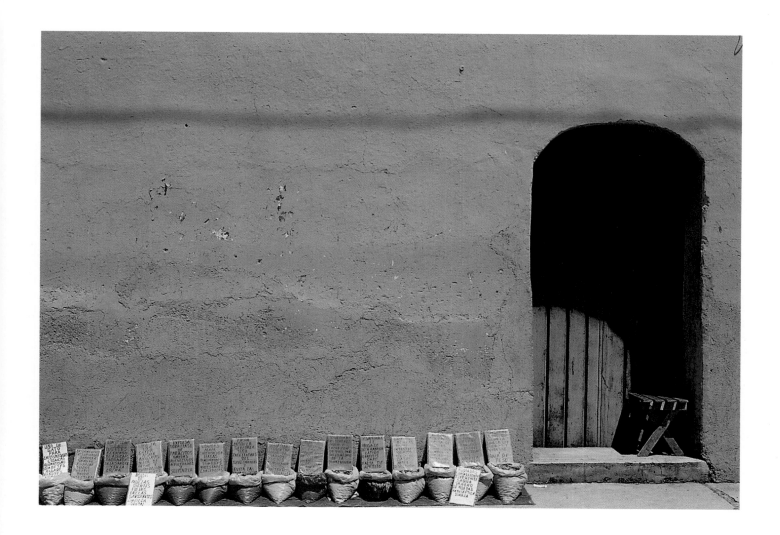

In Colonia del Valle, home of upwardly mobile middle-class people, buyers demand pale colors, never the stronger ones. They look for ivory, Dutch blue, cream. Violet, purple, scarlet red, pistachio, orange, or apricot? What vulgarity! Look at the cans over there, gathering dust! They don't sell!

"In the Colonia Industrial Vallejo all colors are shrill," says the man behind the counter.

"They are bright and riotous. Clients... request orange, blue, tangerine, Neapolitan yellow, and canary. With the influence of English, it is easy to change habits, and some come and say they want 'baby blue.' I tell them I don't have any children, that maybe what they want is called sky blue, and will they please not give me any of that English crap."

Before, one would just paint the house in any

LEFT: *Oaxaca City.* Deterioration reveals the original color of this building. ABOVE: *Oaxaca City.* Street vendor spreads his herbal remedies on the sidewalk against a green wall.

color, as long as it lasted. You covered the walls, and that was it. Now people want to make their houses harmonize with their dogs, their cars, and the city's smog.

In Colonia Guerrero, another popular neighborhood, people want salmon, Neapolitan yellow, lemon yellow, Mexican pink, red, and colonial blue, Prussian blue, magenta, cobalt blue, and cerulean blue. We use a darker tone of cerulean, because the true cerulean is more like the sea, and here, well, those gangs, punk kids, druggies, they come and paint the walls with their graffiti, which sometimes is

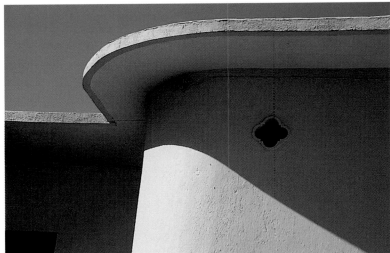

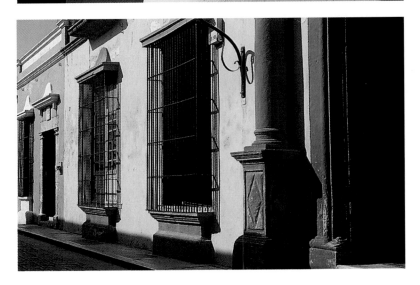

really good to look at, let me tell you, but still, people have to paint their houses often because of those "cats."

Nobody in their right mind would paint their homes in white, flamingo pink, beige or sand: it would be an open invitation for street kids to leave a message in tar black or burnt sienna, in big whorls cursing life.

One day a white wall in Colonia Bondojito sported a new sign in the early dawn:

"The world is born when two kiss."

—Octavio Paz

ABOVE: *Tlacotalpan, Veracruz.* Private Residence. CENTER: *Guanajuato City.* Casa Kloisters. BELOW: *Campeche City.* Entrance to a school within the fortified town. An example of the *palo de tinte* color. RIGHT: *San Miguel de Allende, Guanajuato.* Detail of stairway surround.

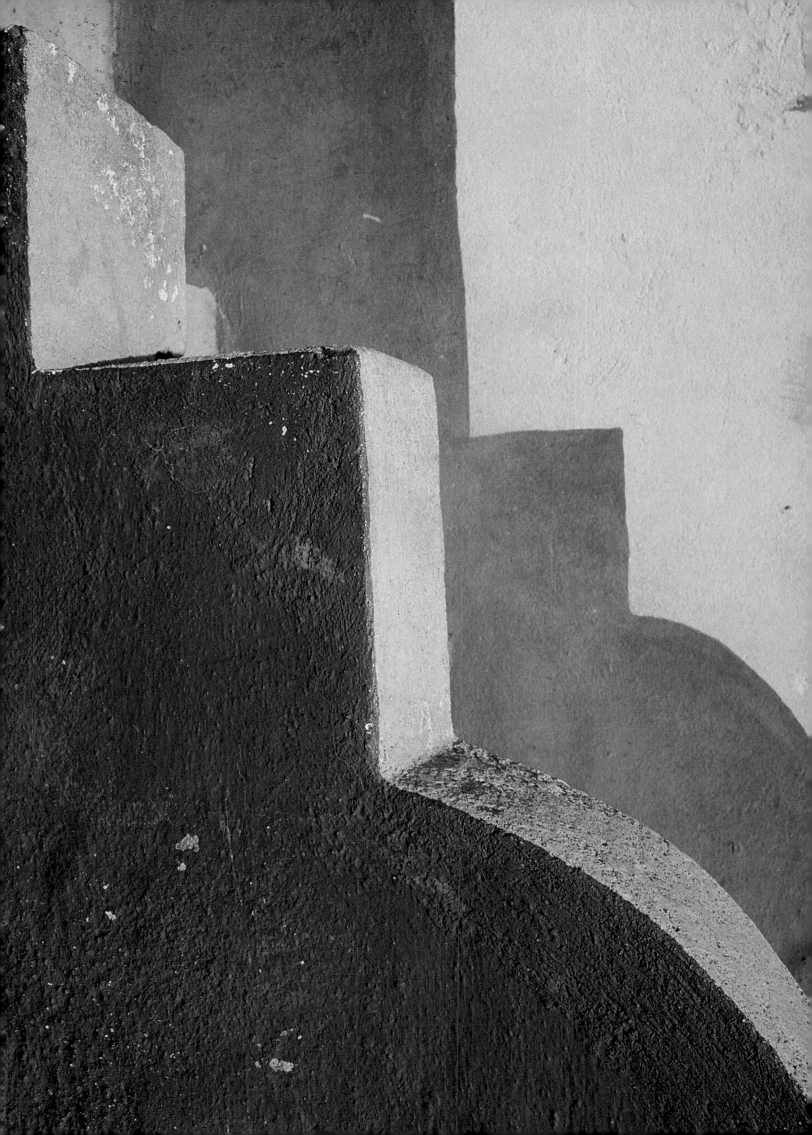

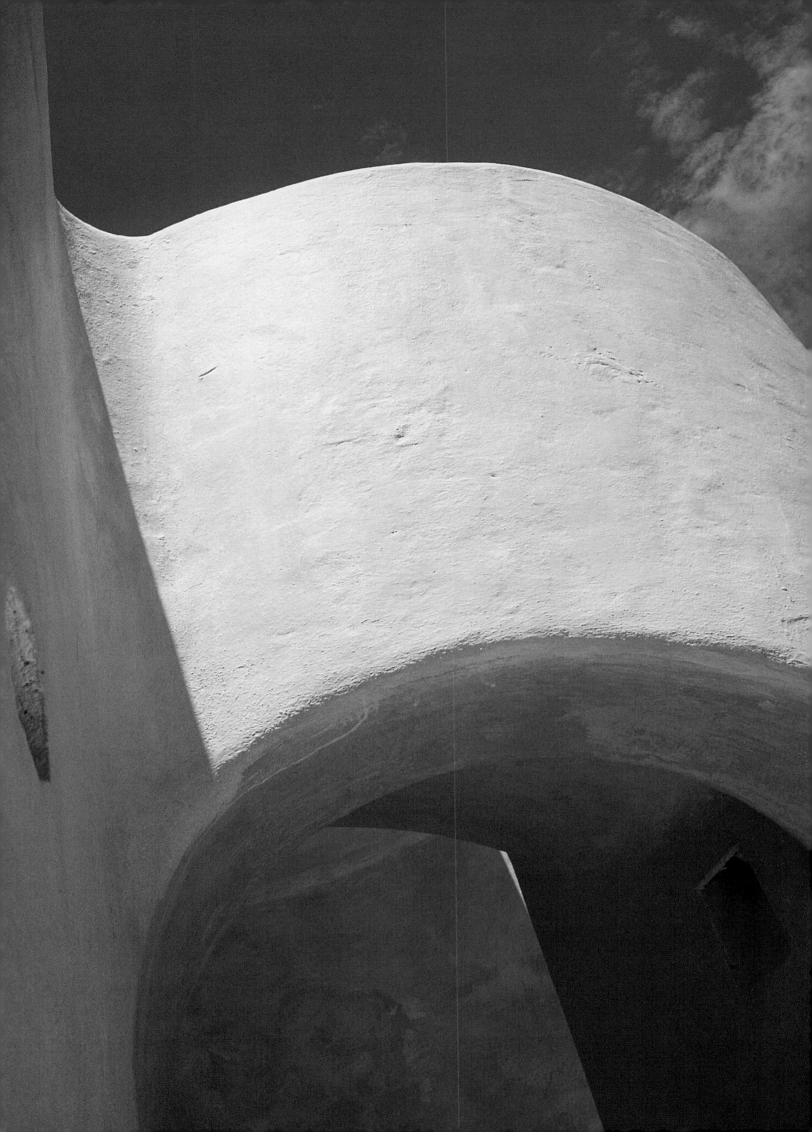

The Space of Light

—Knock, knock.
—Who is it?
—Luis Barragán.
—What do you want?
—The color of your door.

MODERN MEXICAN ARCHITECTURE bears the signature of Luis Barragán. A long queue of Barragán imitators have attempted to stand on his shoulders, and their innovations go back to their source: Barragán. He realized early on that colors shorten or widen space, and just as a small door opens into a huge room and a narrow corridor flows into an area of noble proportions, Barragán drives his imagination from a limited structure to a

LEFT: *Careyes, Jalisco.* Casa Parasol. Architect Diego Villaseñor. ABOVE: *Malinalco, Morelos.* Golf Club. Architect José de Yturbe, 1993.

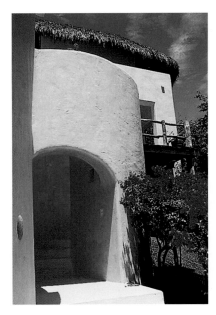

building where light is at home. He explains, "Then I visit the place constantly, at different hours of the day, and I begin to imagine color. I go back to my books of paintings, to the works of surrealists, particularly Delvaux, De Chirico, Balthus, Magritte, and Jesús Reyes Ferreira. I look carefully at the pages, I look at the images, and suddenly I identify some color I had only imagined. Thus I select one color, then another. Later,

I take large pieces of cardboard and I ask the master painter to produce the colors on those surfaces, so that I can set them against the colorless walls. I leave them there for a while, or I switch them around, changing contrasts. Finally I make a decision, leaving the ones I love best."

The different tones of orange, red, and lemon yellow are the product of a mind that tends toward abstraction, science, reflection, and most of all,

ABOVE LEFT: *Careyes, Jalisco.* Casa Parasol. Architect Diego Villaseñor. ABOVE RIGHT: *Careyes, Jalisco.* Casa Parasol. Architect Diego Villaseñor. BELOW: *Tepoztlan, Morelos.* Banana leaves. RIGHT: *Careyes, Jalisco.* Casa Parasol. Architect Diego Villaseñor.

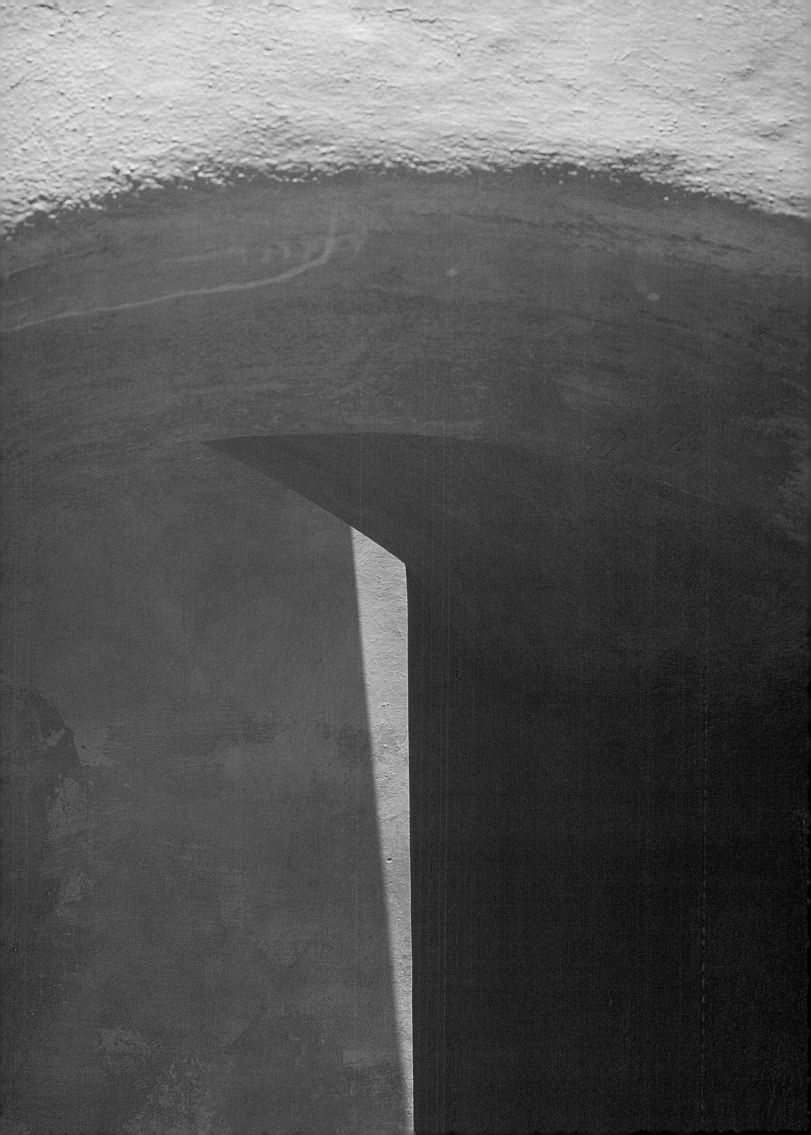

poetry. The knobby walls of a Barragán building make the light vibrate. The reflections that emanate from the walls' texture give the impression of luxury, but Barragán is an austere Franciscan man. Profoundly religious, he searched for serenity and found it in the lines that fall straight down, in walls twenty feet high, in volcanic rock, in water ponds.

Barragán preserves the intimacy of space; he attempts to sift the sunlight. He conceives of aquatic courtyards, and shelters them in high walls. His surfaces are vast: nothing about him is petty. A sober taste can be grandiose. Barragán recovers the old tradition that consisted in flooding exterior spaces with light, while preserving a cozy, almost somber, intimacy.

In Careyes, over the Pacific, even when the walls are painted yellow, when the sun shines on them they are lit from the inside and turn orange. Yellow is found in the earth's minerals, and the ocher dyes are as ancient as the beginning of time. While Imperial China equated yellow with the most holy emperor, we, the People of the Sun,

know that the color symbolizes wisdom and knowledge. The House of the Tower and the Telac House hark back to coral reefs, sand banks, and the sea water that erases all signs of previous presences.

In Careyes, Amanda is overcome by a fine tree that had offered its thin branches to the sun, and was in turn rewarded with multiple bunches of delicate yellow blossoms all over its spare form.

Elements determine colors. Next to the sea, white and blue reign supreme. Perhaps white, the color that embodies all colors, is the only one capable of competing with the sun. Much to our surprise, Homer didn't speak about the color of the sea, nor did he say that the sky was blue. What colors did they know in ancient Greece?

In Careyes, shapes are as round as the sea waves, puffing up like bread dough before baking, displayed before the sun that toasts them along with the sunbathers. Under the intensely blue sky, houses are tangerines, oranges, grapefruit, big slices of watermelon. The walls may overhang the cliff, but our impression is still one of round

ABOVE: *Careyes, Jalisco.* Casa Dos Estrellas. Architect Manolo Mestre, 1995. RIGHT: *Careyes, Jalisco.* Casa Dos Estrellas. Architect Manolo Mestre, 1995.

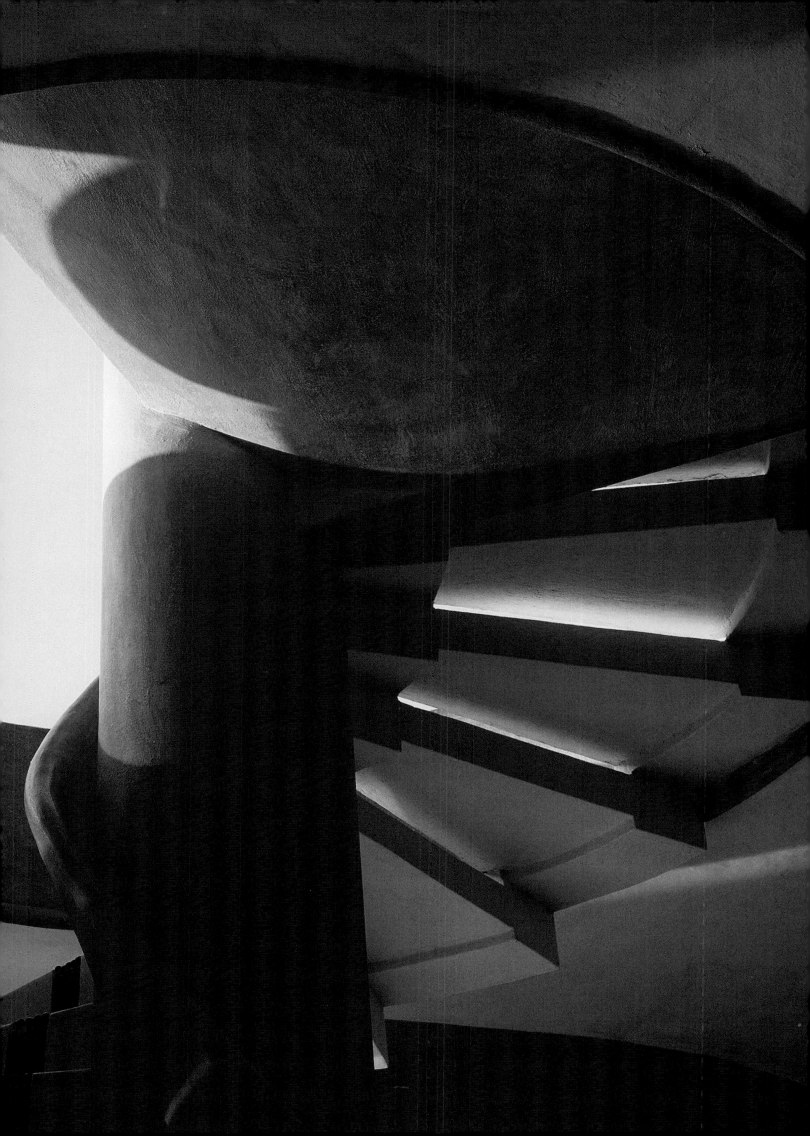

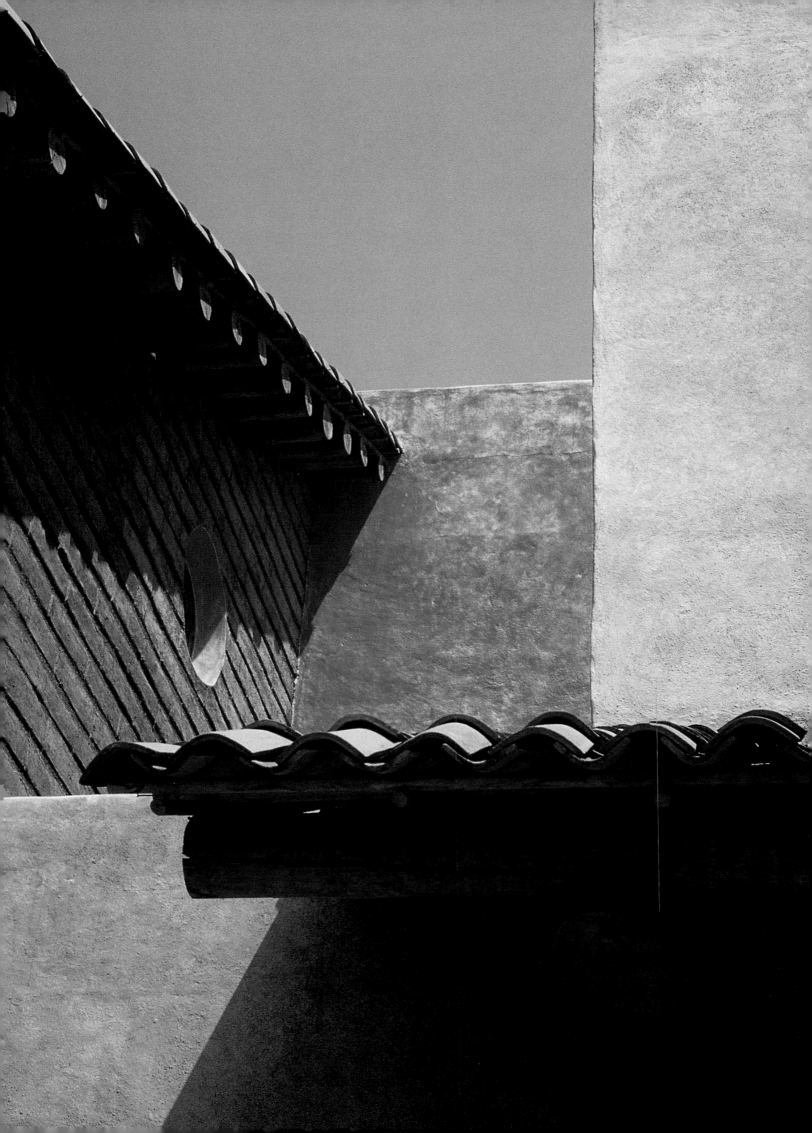

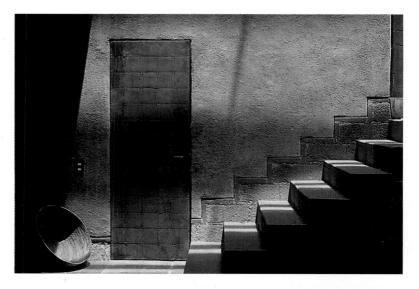

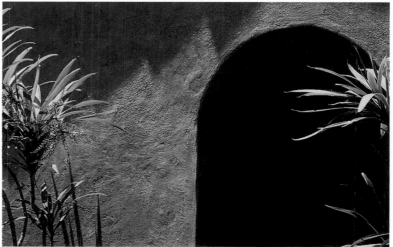

softness. The builders have warm hands, and their hands caress all materials. The materials belong to the earth: great palm roofs tightly woven, beams from the cores of the region's trees, precious woods roasted in the sun, loam and colored soils, obedient clay. The Mediterranean background of architects Diego Villaseñor, José de Yturbe and Manuel Mestre becomes is evident in the houses of Careyes.

In the fifties, the Mexican sky was very blue.

No wonder the first color selected by Barragán was that blue. On another occasion, he saw a construction worker wearing a purple shirt. He said to him, "Lend me your shirt. I will return it to you tomorrow." He made a paint sample with the color and ended up painting part of his new building that same purple.

One afternoon Amanda asked de Yturbe why he had painted his dining room red and yellow.

LEFT: *Valle de Bravo. Rancho de la Peña. Architect Manolo Mestre, 1995.* ABOVE AND BELOW: *Valle de Bravo. Rancho de la Peña. Architect Manolo Mestre, 1995.*

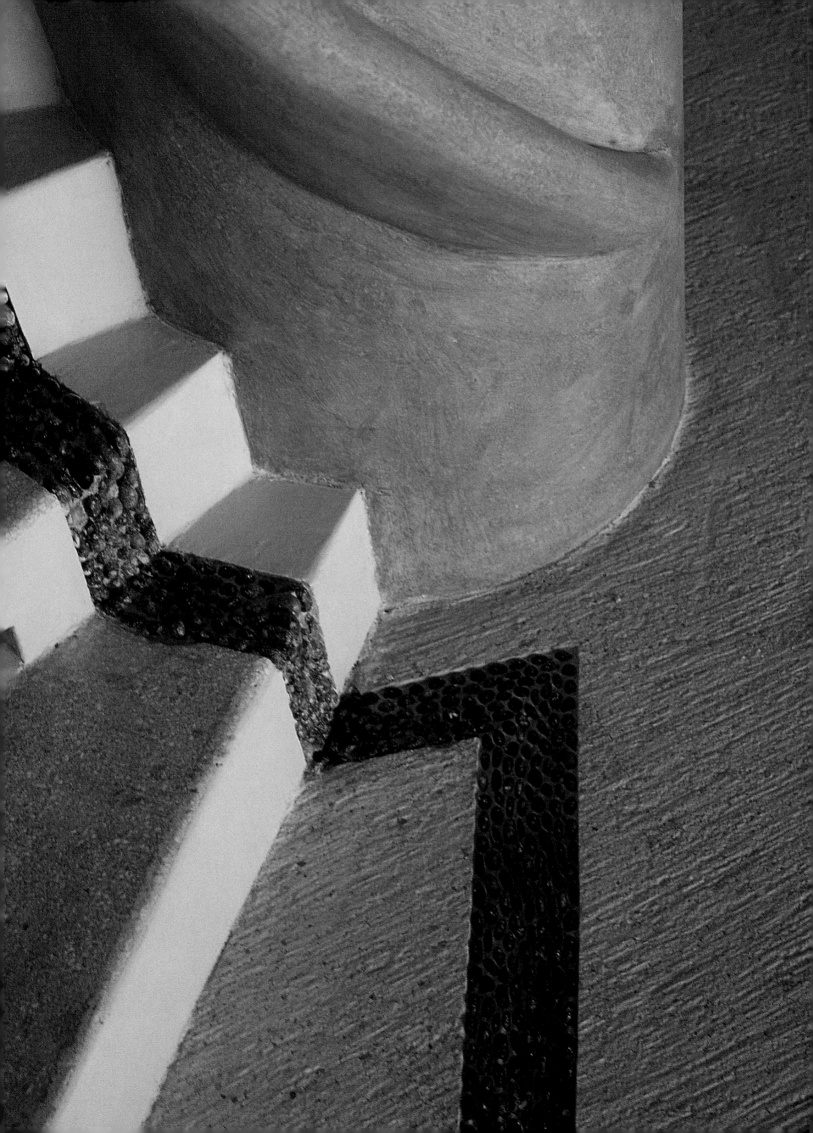

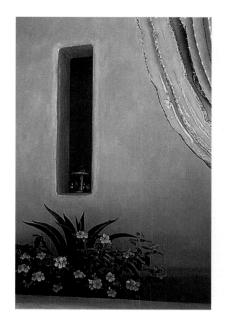

"Because all pyramids were red," he answered. "And the yellow?"

"Because of the hardware stores, of course."

Diego Villaseñor, José de Yturbe, Andrés Casillas, Manolo Mestre, Luis Enrique Uranga, and Emilio Guerrero choose the colors of nature. A blue tower by Villaseñor melts against the sky. The yellow of Telac House is the yellow of the flowers from that tree in the garden. Architects use the materials and colors of the region—not the fuchsia of bougainvilleas, but the color that oscillates between orange and pink. They resort to begonias and to the ocean and all its tones. On the Pacific Coast colors are strong. Blue here is more intense than in the Caribbean—a pastel color, almost a baby blue, a lead blue.

Here, in the Gulf of Mexico, trees have leaves and fruits, but also flowers, like the trees in India.

LEFT: *Careyes, Jalisco.* Casa Dos Estrellas. Architect Manolo Mestre, 1997. ABOVE LEFT: *Careyes, Jalisco.* Casa Torre. Architect Diego Villaseñor. ABOVE RIGHT: *Careyes, Jalisco.* Las Alamandas. Architect Gabriel Nuñez, 1982. BELOW: *Careyes, Jalisco.* Casa Dos Estrellas. Architect Manolo Mestre, 1995.

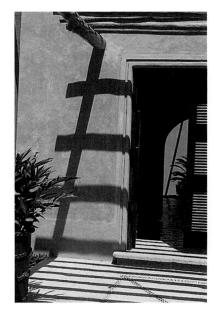

Every year in March the jacarandas cover the ground with a purple rug. And the red colorines have blossoms that can be eaten with eggs. Then there is the yucca flower, called *equizote* in Zacatlán, white and delicious; and the nopal cactus gives thorny *tunas* after it blooms. The *maguey* blooms before it dies, so its flower is one of agony. The *madroño* has a white flower and glassy branches that break easily.

In the dining room in Careyes, the red color in the crystal pitcher invites appreciation from the guests and is a point of convergence, a sunset warmth that brings everyone together. The watermelon too, with a knife buried in its flesh, has weight, even when it is made out of water. Sensibility and imagination transform it into a canoe of water, then into a fruit bowl, holding cut apples, sliced melon, orange wedges, tangerines,

LEFT: *Careyes, Jalisco.* Las Alamandas. Architect Gabriel Nuñez, 1982. ABOVE TWO PHOTOS: *Careyes, Jalisco.* Las Alamandas. Architect Gabriel Nuñez, 1982. BELOW: *Las Alamandas.* Palapa (thatched roof terrace) with Oxacan burnished black clay pot.

pears, guavas, grapes in all the colors of the rainbow, all contained in the hard green belly of a watermelon. But it is also a flower vase! Honeysuckle, marigolds, carnations, baby's breath, and wild roses show the watermelon to be useful once more. It is a popular art that teaches us a particular form of conviviality that is at once fruity, floral, and luminous. The watermelon displays its pulp, its black seeds the only interruption in its succulent red surface. No one can defeat a watermelon: not time, not movement. Only teeth can grind it, make it water. Mexico is the country of cool fruit drinks in large glass barrels: jamaica, lemonade, tamarind, alfalfa.

If the plates placed on the Tamayo pink tablecloth are Talavera ceramics from Puebla, all the better. White and blue talavera came from Puebla in the 16th century, and later it became yellow,

ABOVE AND BELOW: *Mexico City.* Casa Magdalena S. de Yturbe, 1996. Architect José de Yturbe. RIGHT: *Mexico City.* Casa Magdalena S. de Yturbe, 1996. Architect José de Yturbe.

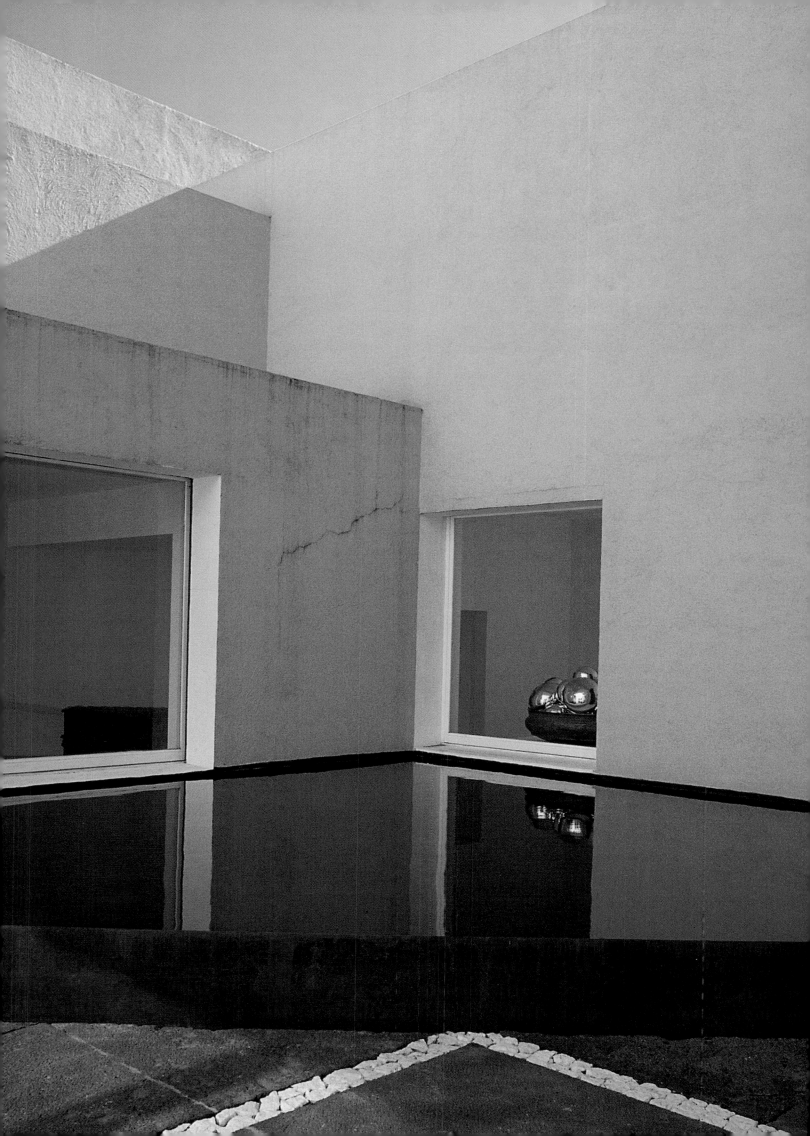

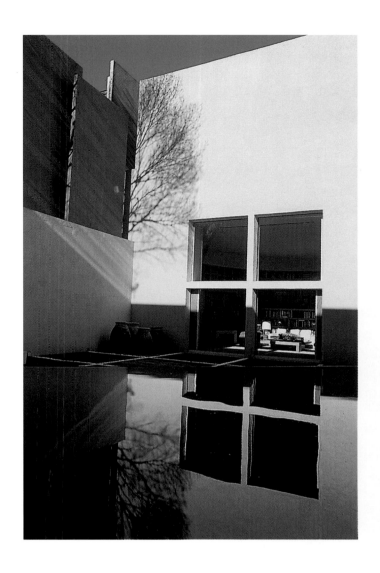

green, and red. The first Spanish potters came to Puebla from Toledo in 1531, and with the dexterity of their hands and the power of their kilns, they put beautiful, delicate soup tureens, bowls, and plates full of laughter in all the kitchens and cupboards of the city. Mugs and pitchers transmitted new ideas and beliefs that evolved into the habits of the community. Complete china sets spoke of the human capacity to create. Designs of lines and col-

ors came and went, giving everyday utensils an unexpected presence. Mexicans had been extraordinary ceramicists before the Conquest. Now the maestros—from Tzintzuntzan, Metepec, and Oaxaca, or from Patamba, the place of glazed green ceramics, mixed their knowledge with the techniques brought from Spain. In this way, they produced works of art of the caliber of Santa María Tonantzintla, the most deliriously beautiful

LEFT *Mexico City.* Casa Magdalena S. de Yturbe. Architect José de Yturbe. Dining room showing use of pre-Columbian red.
ABOVE: *Mexico City.* Casa Magdalena S. de Yturbe. Architect José de Yturbe 1996.

of all, where lecherous angels have red lips, and are loaded with grapes, bananas, and aphrodisiacal pineapples.

The best-loved painter of the architects who formed the "Barragán School" is the painter of watermelons, Rufino Tamayo. He is also the favorite of Octavio Paz, who wrote about him and his use of color in his book, *Tamayo in Mexican Painting*: "Xavier Villaurrutia was one of the first to note that the solar element accompanies the painter on all his adventures. Tamayo is a child of the earth and the sun. Childhood is alive in his work, and its secret powers of exaltation are present in all his

paintings. During his first period, he gave sensuality and freshness to tropical fruit, nocturnal guitars, women of the coast or the high plateau. It illumines today his highest creations. His matter, at the same time dense and juicy, rich and severe, is made of the substance of this secret sun. A sun, which while being that of his childhood, is also that of the childhood of the world, and even more, the same that presided over the astronomical calculations of the ancient Mexicans, the ritual succession of their feasts and the sense of their lives. But the presence of the solar element, being positive,

LEFT: *Zacatecas City.* Hotel Quinta Real. ABOVE: *Careyes, Jalisco.* Casa Torre. Architect Diego Villaseñor.
BELOW: *Careyes, Jalisco.*

engenders the reply of a contrary principle; the essential unity of the world manifests itself as a duality: life feeds on death. The solar element rhymes with the lunar. The male principle sustains in all of Tamayo's pictures a dialogue with the lunar principle. The moon, which glows in some of his pictures, rules the hieraticism of those women who lie down in the position of the sacrifice. Necessary complement of the sun, the moon has given to this painting its true equilibrium—not in the sense of the harmony of proportions, but in the more decisive one of inclining the balance of life under the weight of death and of night. And this same lunar

principle may be the origin of the refined delicacy of some fragments of his paintings, always closer to somber and barbaric sections. Because Tamayo knows instinctively that Mexico is not only a dark and tragic country, but also the land of the hummingbird, of the feather mantles, the *piñatas*, and the turquoise masks."

Before the outbreak of World War II, Elsa Schiaparelli created the color "shocking pink," but the world's most beautiful women— her clients in Paris— used it to line their coats because the color seemed too scandalous. In contrast, the "Tamayo pink" became acceptable from the

ABOVE AND BELOW: *Careyes, Jalisco.* Casa Torre. Architect Diego Villaseñor. RIGHT: *Careyes, Jalisco.* Casa Torre. Architect Diego Villaseñor.

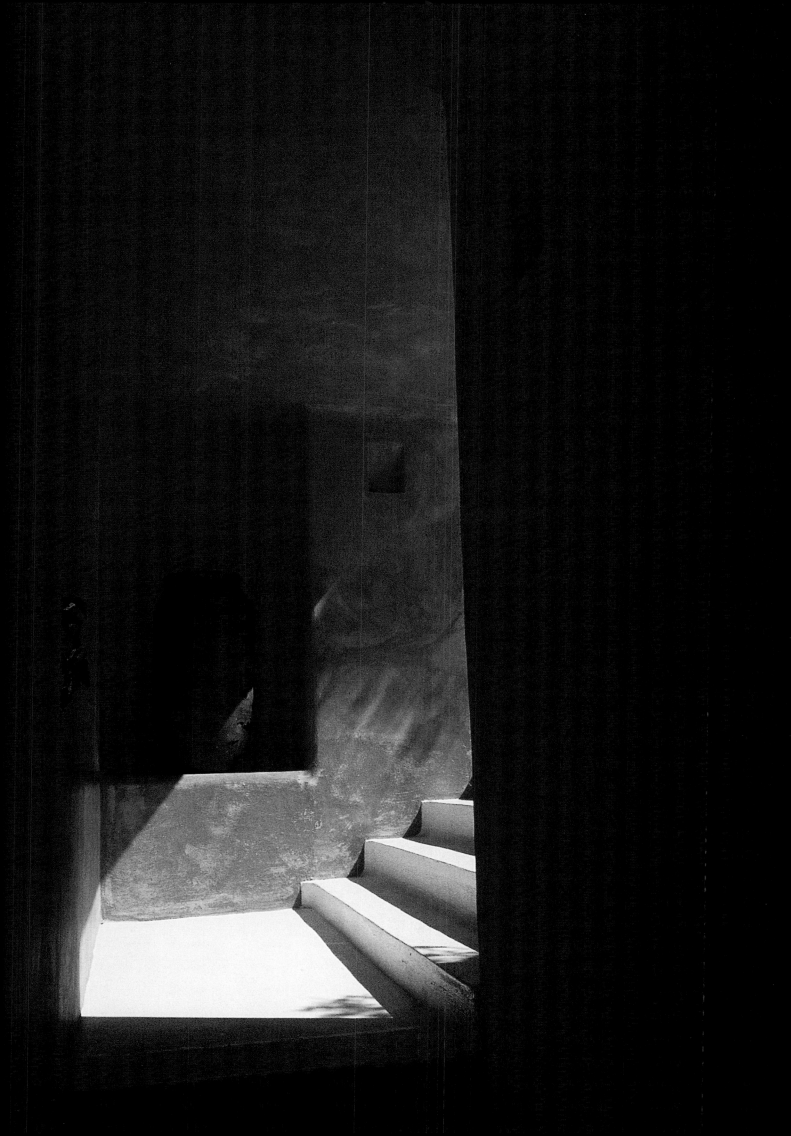

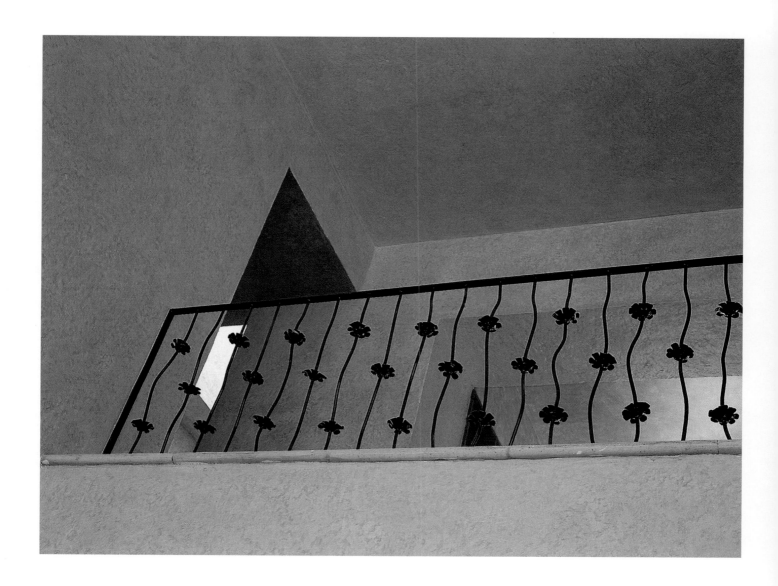

start, because a great artist had made it eternal.

—Knock, knock.

—Who is it?

—Luis Barragán.

—What do you want?

—The color of your door.

—But it is a very poor door!

—No matter. That's why I like it. It's so simple. The peasant opens the door and is impressed by the stature of the engineer. In San Juan de los Lagos, Barragán chooses a lavender wall and one other portal framed by two intensely blue strips. He discovers a lookout from where the eyes can wander through a vast cornfield. He finds a wooden double gate that filters light through its grate and gives a patio the appearance of a convent.

Luis Barragán popularizes the vernacular, throws a bridge between red clay and Delft bisque,

ABOVE: *Mexico City*. Casa en Reforma, 1998. Architect Luis Enrique Noriega.

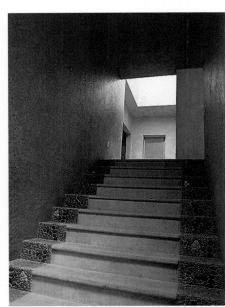

between magenta and the Congo yellow of hardware stores. He fuses the natural beauty of a place with popular art. Cut-out tissue paper is our lace from Bruges. A simple skylight creates a mystical ambiance. A small cup from Sayula, white and blue, shines more than the pigeon blood of a Tanagra vase. A wooden chair with a rush seat acquires the dimensions of Van Gogh's chair. Nothing is superfluous, and the simplicity of each object stirs the soul. These are things that breathe to their heart's content, and they teach those who look at them how to breathe. Perhaps that is the ineffable mystery of aesthetics, the mystery of breathing.

The cupolas of many churches are flowers turned toward the earth. Flowers that are stars, that are plates, that are earthenware, that are pottery, that are painted plaster, that are cups and bowls high up there, ready to fall on the heads of the devout.

ABOVE: *Mexico City.* Casa en Reforma, 1998. Architect Luis Enrique Noriega.

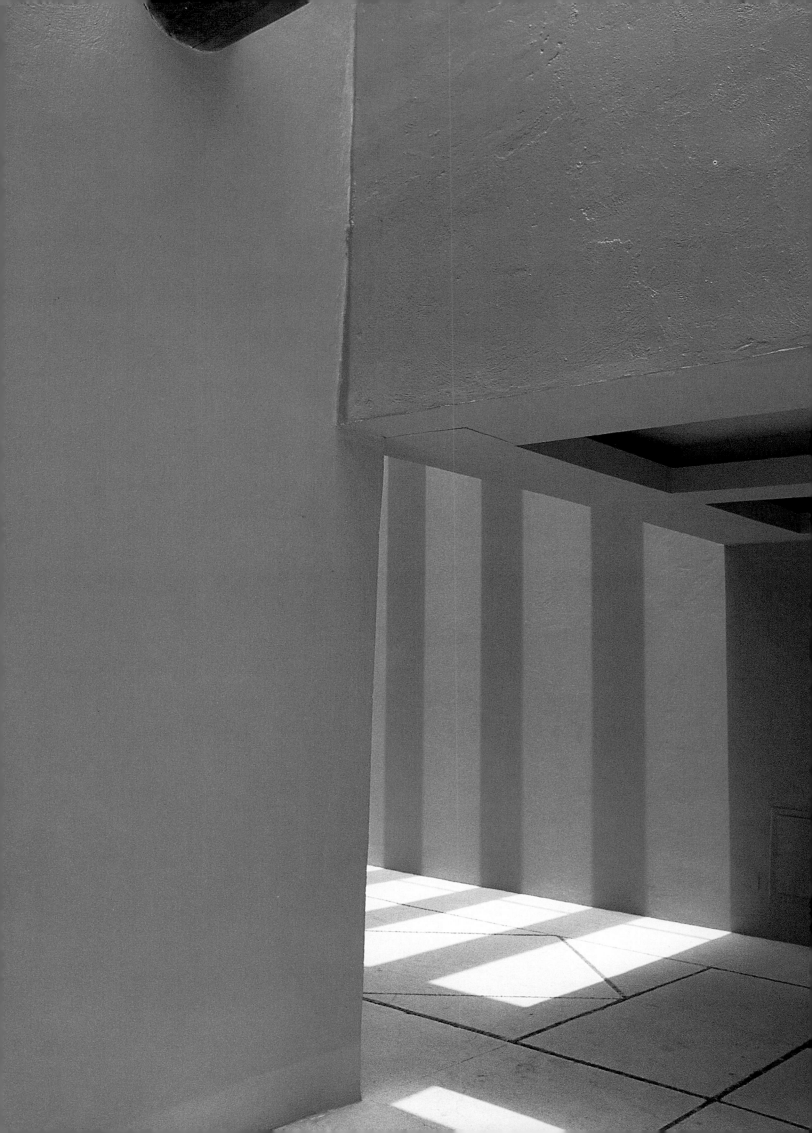

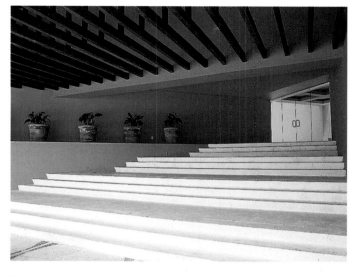

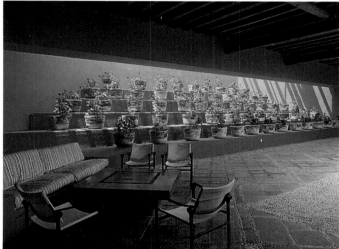

There are twenty-eight distinct regions in Mexico, distinguished by deserts or volcanoes, caverns or valleys, hills and shores. In a few minutes, one can go from a cornfield flanked by *maguey* cacti to a field where broad banana leaves take flight. In the Valley of Mexico, fruits and flowers receive the energy of a sun that paints them in many colors. The tender green of alfalfa, the green of the new corn husk that is same green used by Miguel Covarrubias in his great and juicy maps. Colors sing, and that is why we Mexicans intone yellow or purple songs, depending on the occasion. "Look at that color!" Yes, colors have musical tonalities. In the presence of a field covered by newborn green grass, one feels like singing, shelling peas, taking them out of their pods and threading them like pearls for a necklace or beads for a rosary, full of gratitude for life. Before the height of the mountains and the violet hue of their mystery, before their solemnity, like giant females sitting to see the show, one could intone dramatic arias of opera, shouts of exaltation or amazement, a catharsis of arpeggios that vibrate like those of the rainbow after a shower.

The rays of the sun reflected in the water are not only light, but music. The *mariachis* know that well, dressed in magenta and parrot green, with their golden yellow ties and their pink and purple ornaments. They say that the sound that comes out of their trumpets is yellow, while the violins produce a lilac and pink sound.

The man who has best taught us how to comprehend the meaning of what we see is the Englishman John Berger in *Ways of Seeing*. In the act of reflecting on Mexican art, it is impossible to forget John Berger because popular art is the art of everyday life, frugality, and survival. It is as essential as the earth. The wooden cradle carved out of a tree trunk for the newborn child is as substantial as the cluster of corn that hangs from the beam, or the yellow straw mat braided with the dreams of the Sierra Puebla, or the white hammock that soothes anxiety in Yucatán. Manuel Jiménez from Oaxaca, an adobe maker, would laugh if he were told that his work is "divine, majestic, inspired, fantastic." Cutting cane one day, he realized that the green wood of the *tzompantle* was easy to

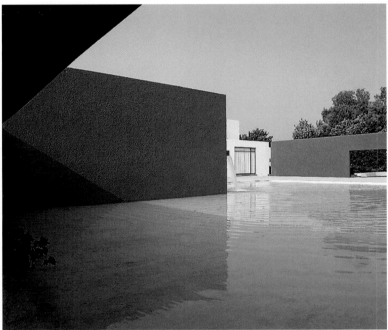

carve, and thus he started to make red and blue lions, purple, green, and yellow tigers, and pink dogs barking at the moon, as expressive and mysterious as those of Tamayo. He is a popular artist who sculpts his figures instinctively, and chooses his colors "just because," with a freedom that comes from his innocence. It seems that he was born before original sin, and no one limited his natural instinct or restrained his creative ability.

In *The Meaning of Life*, Antoine de Saint-Exupéry tells how he traveled at night in a third-class car, in the company of Polish miners who slept in exhaustion. He describes their grimy bodies, folded among cardboard crates. Their faces looked like a handful of clay; their painful and tired features made them resemble a permanently open wound. All of a sudden, between the body of a man and a woman who slept like castaways,

ABOVE: *Cuadra San Cristóbal, Mexico City.* 1967–68 Architect Luis Barragán. BELOW: *Cuadra San Cristóbal, Mexico City.* Architects Luis Barragán and Andres Casillas, 1967–1968. RIGHT: *Mexico City. Cuadra San Cristóbal.* Architect Luis Barragán.

Saint-Exupéry saw the face of a child who had elbowed his way between them. From those rude bodies in coarse clothes, a child, like a sun, had been born. Dazzled by his beauty, Saint-Exupéry wrote that his was the face of an artist, perhaps the face of the child Mozart, a bud capable of stirring the hearts of all gardeners. And he wondered whether there would ever be a garden for this child, or would such a Mozart always lie buried under his parents' snores and muddy shoes.

From the rough and calloused hands that have known slave's work, popular art is born, at least in Latin America. It is not a pastime, but a necessity. Artisan ingenuity is a product of poverty. Artisan children may not be a Mozart, but they are, despite all the inclemencies of their lives, creators as mysterious as Rufino Tamayo, Francisco Toledo, and Juan Rulfo.

If all celestial bodies are identified with a particular color, the Earth, too, must have its own. Astronaut Yuri Gagarin told us that during his first flight into space he was surprised to see that, from space, the Earth is blue. No other realization has moved us so deeply. We thought only the sea was blue! We were stirred, because blue is the color of serenity and compassion. If we see ourselves that way within the universe, then we must have billions upon billions of light years of future life. Our own color is a signal sent from beyond. All colors are oracles. They tell us who we are. They reflect us.

We are what we eat, but also what we wear. Contradictions are revealing. There are beggars who are princes. The Pope's attire and the Vatican's pomp belie Christ. Luxury is an affront in its color. The symbolic use of color has been indispensable in all areas of life:

ABOVE: *Mexico City.* Torres de Satelite. Architects Luis Barragán and Mathias Goeritz, 1956.

All colors are oracles. They tell us who we are. They reflect us.

religious, mythological, ceremonial, domestic. Colors establish implicit agreements among all civilizations. The people of the Americas have profound similarities to people of other continents. Popular Yugoslavian art, for instance, is very similar to Mexico's. The Philippines, and maybe the whole of Southeast Asia, are culturally connected to our country. Our affinities are greater than our divergences. Perhaps it is poverty that homogenizes

us. All poor people have a popular art: color is also an economic stance. In general, the most strident and unthinkable colors are those of workers, because their ingenuity and craftsmanship are expressed through color.

Time, water, sun, and even the human gaze change colors. A stone loses its original tint and acquires the tonalities of time as it is stepped over. Brown is the color that changes the least, and yet it

ABOVE: *Mexico City.* **Diego Rivera Studio.**

yellows, turning autumnal and brittle, so the leaves of trees must contrive to give it new textures. Franciscans resorted to the brown coarse robe because its color was the most enduring, and the one that least showed dirt.

The quality of brown gives us one measure, our humanity. The Mexican people are a brown people, with brown eyes and black hair, as black as the hair of the people from India. We are all Indians. The permanence of brown, its durability, helps us withstand all assaults, the ravages of all elements. We are the people of the sun, and our blood is called to return, as the Náhuatl philosophy tells us, to its place of rest. We all go back, finally, to our origin, to the place of mystery.

—Knock, knock.

—Who is it?

—The Old Woman.

—What do you want?

—A ribbon.

—We already gave them all to you. What did you do with them?

—I painted the earth with all the colors, and gave Mexico the most shocking ones.

—What will you reveal to us about the world and ourselves, Old Woman?

If the Conquerors came to despoil our flowers in order that their own might live, we have given them, in exchange for their smallpox, the fire of our colors. We renewed the old European culture, injecting it with new life and with the realization that Europe was not the center of the universe. We gave them the suspicion that there might be other divine powers. This new cosmic balance changed their relationship with other continents. They no longer believed they ruled the world. They gained a less pretentious sense of their identity within the cosmos. We were responsible for stretching the spectrum of their light. We taught them that just as the grandfather gods Quetzalcóatl and Tezcatlipoca turned into trees to uphold the sky, we too can be cosmic trees dispensing light, those trees that can be seen at night, radiating colors from the four cardinal points of the celestial vault.

LEFT: *Mexico City.* Interior of a modern public building that demonstrates the use of popular colors in modern architecture.
ABOVE: *Mexico City.* Hotel Camino Real. Architect Ricardo Legorreta.

Bibliography

Arquiologio, Pintura Mural Vol. iii #16. Consejo Nacional para la Cultura y las Artes, Instituto Nacional de Antropologio e Historia.

Broken Spears: The Aztec Account of the Conquest of Mexico. Translated from Náhuatl (Aztec language) into Spanish by Angel Maria Garibay. Edited and with an introduction by Miguel Leon-Portilla. English translation by Lysander Kemp. Beacon Press, 1992.

Corcuera, Marie Pierre Colle, and Ignacio Urquiza. *Casas Del Pasifico.* ALTI Publishing, La Jolla, 1994.

Cortés, Hernando. *Five Letters of Cortés to the Emperor.* Translated and with an introduction by J. Bayard Morris. W.W. Norton and Co., Inc., 1962.

Dennis, Landt, and Lisl Dennis. *Morocco.* Clarkson Potter Publishers, New York, 1992.

Díaz del Castillo, Bernal. *The Discovery and Conquest of Mexico.* With an introduction by Irving A. Leonard. Farrar, Straus & Giroux, 1956.

Dürer, Albrecht. *Records of Journeys to Venice and the Low Countries.* Dover Publications, 1995.

Fuentes, Carlos. *The Buried Mirror.* Houghton Mifflin, 1992.

Garibay, Angel Maria. *Historie du Méchique.* Mexico, Editorial Porrua, 1965.

Guild, Tricia. *Life in the Country.* Conran Octopus, Folio Editions SA, Barcelona, 1995.

Guild, Tricia. *Tricia Guild in Town.* Rizzoli, New York, 1996.

Heyden, Doris, and Paul Gendrop. *Pre-Columbian Architecture of Mesoamerica.* Rizzoli, New York, 1980.

Historia de los mexicanos por sus pinturas. Paraphrase of pre-Cortesian pictographic manuscript recorded shortly after the Conquest in the 16th century.

Portugal, Armando Salas. *Barragán.* Rizzoli, New York, 1992.

Reyes, Alfonso. *Visión de Anáhuac.* Ediciones Cultural Mexicanas, Mexico City, 1959.

Stuart, George E. "Ancient Cacaxtla." *National Geographic,* Vol. 182 #3, National Geographic Society, Washington, D.C., Sept. 1992.

Mexicayotl Chronicle. A text originally in Náhuatl published at the end of the 16th century or early in the 17th century, attributed to Hernando Alvarado Tezozómoc, grandson of Emperor Moctezuma (son of Moctezuma's daughter and a Spanish father). Translated into Spanish by Adrián León. Published in Mexico City, 1949.

Ypma, Herbert. *Mexican Contemporary.* Thames & Hudson, London, 1997.

ABOVE: **Photographer's residence.**